The Life of Christ

IN MASTERPIECES OF ART

Selection of masterworks with an introduction
by MARVIN ROSS

HARPER & BROTHERS, PUBLISHERS, New York

A CHANTICLEER PRESS EDITION

The Life of Christ

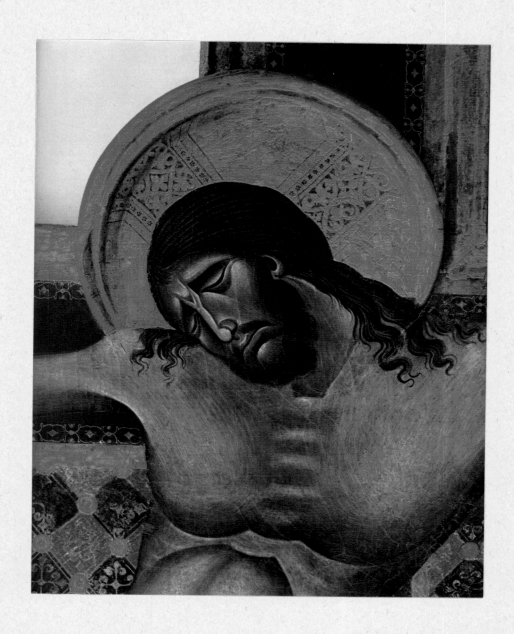

in Masterpieces of Art

AND THE WORDS OF THE NEW TESTAMENT

1317509

PUBLISHED BY HARPER & BROTHERS NEW YORK

Prepared and produced by Chanticleer Press, Inc., New York

LIBRARY OF CONGRESS CATALOG CARD NO. 57-8167

PRINTED IN SWITZERLAND BY CONZETT & HUBER

Overleaf: Crucifix (detail)

CIMABUE (ca. 1240–1302)

Church of San Domenico, Arezzo

The Works of Art

The Works of Art (continued)

Introduction

THE LIFE OF CHRIST IN ART

HE image of Jesus Christ has been one of the great subjects of art for almost two thousand years. And, for most Christians, that art has been almost the only source of their conception of His appearance. Yet, although many of us have a quite definite idea of what He looked like, no contemporary likenesses or written descriptions of Him are known to have been made.

There are, of course, legendary accounts of portraits of the Savior that were painted during His life on earth; but, although these stories may be poetically true, they are not to be taken literally. Writing several centuries after the Ascension, John of Damascus and Andrew of Crete referred to pictures of Christ in Jerusalem and Rome that some claimed had been made by St. Luke. There are even various medieval pictures showing this Evangelist at work on portraits of either Christ or the Virgin; one of the best-known of them, by Roger van der Weyden, depicts the Saint painting the Madonna in his studio. Although such beautiful pictures may not be authentic, they bear witness to the desire for a likeness of their Redeemer that arose early among Christians.

In our one authentic source of the life of Jesus, the Gospels, there is no physical description of Him. Surrounded as they were by pagans and by images of pagan gods, the Evangelists strove to avoid materialistic interpretations, and instead sought to establish only the spiritual truth of Christ as the Light of the World. By their omissions, they made it quite clear that, compared to His teachings, such matters as the cast of His features and the coloring of His complexion were of no consequence. With purpose, then, they recorded nothing about the physical appearance of Christ.

Perhaps we may find a further explanation of the absence of contemporary portraits in the fact that He and His disciples came from modest walks of life. Joseph was a humble carpenter, and Jesus, as a youth, applied Himself to the same calling. The disciples —for example, Simon, Andrew, James, and John— were simple men, living on a social level where the commissioning of portraits or busts by an artist was hardly likely. Moreover, as a result of the Judaic code in which they had been reared, images or pictures of God or prophet would have seemed idolatrous to them. Still, no such taboo would have prevented a written description; so we must conclude that that omission in the Gospels was made deliberately, for spiritual reasons.

As Christianity spread in the pagan world, the desire for pictures of Christ increased. The pagans had always been accustomed to representations of their gods and goddesses, and they could not easily forego their need for visible symbols as they became Christianized. There was also the problem of conveying the teachings of the Gospels to the many who could not read, and for them instruction was greatly simplified by the use of pictures. Scenes intended to convey the message of the Gospels required that representations of Christ as He might have appeared

should be displayed in holy places and churches. We today are the inheritors of the resulting attempts at such portrayal.

At first—even within a single city such as Rome, where Peter and Paul had preached—the concepts of Christ varied greatly. The type most familiar in painting, sculpture, relief, gold-glass, and other media was the Good Shepherd. Representations of gods as shepherds were traditional in the Hellenistic world; and besides, the simile had been applied to Jesus Himself in the well-known passage in the Gospel of St. John. In what manner, then, could He have been presented more naturally than as the beneficent guardian of His flock?

Variations of this youthful and ideal type persisted for centuries. Later, pictures of a bearded Christ began to appear. This also was a traditional type, and came, perhaps, from the Holy Land: in such an aspect had great teachers and spiritual leaders been portrayed. It was, in a way, a more compelling view, in that it depicted one who had more of the appearance of a great thinker and spiritual teacher than did the beardless, idealized Good Shepherd.

During succeeding centuries, the image of the bearded Christ varied according to the ideas and ideals of each period. These changing concepts and the differing forms in which they were expressed reflected not merely the styles of art in each age but the whole tendency of thought and belief, the very nature of religious faith.

The development of an iconography for the events in the life of Christ proceeded along similar lines. No paintings or sculptures representing events in the Gospels were made during His days on earth, and for a long time the prejudice against images prevented artists from inventing a manner in which to represent His life. But with the spread of Christianity, as we have said, a desire arose for visualizations of Gospel scenes, for pictures that would serve in teaching the multitude who could not read. In response to this need, various patterns for depicting places and events in the Gospels developed over the centuries. It should be added that, since artists in those days were rarely well educated and knew that any deviation from accepted doctrine would be quickly condemned, they relied for their interpretations on those who knew the story and the message it contained.

The earliest Christian paintings illustrating scenes from the life of Christ are believed to be those in a chapel at Dura Europos, a Roman outpost on the Euphrates near Bagdad, which was abandoned about 250 A.D. The tradition followed in these pictures seems to have been developed in or near the Holy Land. Intended mostly for instruction and decoration, they have little artistic merit. Primitive Christian art of this character continued to be produced in and around Palestine and Syria for perhaps two centuries. It eventually spread into Egypt, where its last manifestation occurred in a chapel at El Bagawat dating from the first half of the fourth century A.D. Then that early tradition disappeared, swept away by the totally different and highly developed art brought into the Holy Land by the Byzantine emperors.

Meanwhile, early Christian art of a different character was flourishing in another center: Rome. The paintings on the walls of the Catacombs, those subterranean chambers where Christians worshiped and were buried, preserved an unbroken tradition from the second to the fifth century.

The first paintings and sculptures in the underground chapels and cemeteries were mostly funerary, or dealt with the afterlife. They depicted the deceased in attitudes of prayer, such subjects as Daniel in the Lions' Den, signifying the Resurrection, and the miracles, particularly those prophetic of life after death. Symbols abounded, the cross prevailing; and, as in our day, the dove denoted peace, the peacock paradise, the anchor hope. Characterized by directness and appealing simplicity, this un-

pretentious art was all that was within reach of a religious sect subject to persecution at almost any time or place.

But with the conversion of the Emperor Constantine the Great in 312 A.D., changes of the greatest magnitude took place. Persecutions came to an end. Christianity, which had been only one of many Oriental cults then practiced within the Roman Empire, became the state religion, and grew to a point where it gradually displaced all the others. Christians were no longer looked upon as outcasts, and their numbers were swelled by a flood of converts—not only the slaves and the poor but members of the great families, the rich, the army, and the officials of the empire. The formal organization of the Christian Church, begun by St. Paul, enabled the new religion to meet the demands put upon it by the great number of new members.

Thereafter Christian art was no longer limited to funerary themes, or to the catacombs or chapels in outlying regions of the empire. Worshipers and artists of the new faith at last could come out into the open, without fear of torture, crucifixion, or death in the amphitheater. Further, the Emperor and many of his family began building churches—in Rome; in Constantinople, the new Rome on the Bosporus; in cities frequented by the court, such as Trier; in the hallowed places of the Holy Land. Not only were the buildings themselves magnificent, but the greatest artists of the Hellenistic and Roman worlds were called upon to decorate them with frescoes, mosaics, and sculpture, and with metalwork wrought in gold and silver and adorned with precious stones. The art of the empire had theretofore had but one dominant note: the glorification of the emperor. Now Christ Triumphant became the exalted figure, the center of every work. Before this burst of creative splendor, the earlier Christian art forms were pushed aside; from it came the concepts that dominated all of Christian art thereafter.

The desire to express the new spiritual freedom in ecclesiastical structures and decorations was not confined to Emperor and State. Affluent converts built churches, monasteries, and chapels, and filled them with works of art. Artists found that patrons still required imperial trappings and imagery, but expected them to be centered on the figure of Christ instead of the emperor. Such a form of expression was not out of harmony with the idea of Christ as Conqueror, and artists everywhere met the new demand. Much of their work, however, has perished under the erosion of time.

In the Holy Land, for example, none of the great series of Christian representations from the centuries immediately following Constantine has been preserved. The mosaics, frescoes, sculptures, and other decorations created for the churches endowed by him and his family are no longer extant. We know, however, that the decorations of these churches conformed to the Hellenistic tendency of art throughout the Roman Empire during this period. It is probable, too, that the imperial art adorning the churches in Jerusalem, Bethlehem, and other sacred places in the Holy Land formed a basis for the Christian art of that area—though tinctured, perhaps, by such local expression as that noted in the chapel at Dura Europos.

In other famous centers of the early Christian period, too, few significant examples of art have been preserved. Antioch, where the followers of Christ were first called "Christians," has nothing left standing above ground level. Certain floor mosaics of great beauty, reflecting the taste of a patrician and prosperous city, have been unearthed; but they show either purely decorative designs or pagan subjects. The latter may have continued in use after their original meaning had been forgotten; and in any event, a floor would not have been considered an appropriate place for scenes of Christian significance.

Alexandria, with its world-famous library, was the core of Hellenistic culture, and its Christian art is believed to have been Hellenistic in feeling; but this is conjectural. Of the art of Constantinople itself, little remains; but that little, from the fourth

and fifth centuries, is of a very high order. Constantine called artists from all parts of the Roman world to his new capital, so that the result, as can be seen from the little that has survived, was a rather eclectic kind of art.

Rome, where the Apostles Peter and Paul went to preach and eventually to suffer martyrdom, has preserved from this period the greatest number of works depicting the life of Christ. In that city, prior to Constantine's Act of Tolerance, Christian art had been hidden—figuratively in symbolism, literally in sepulchral darkness. Now it became a triumphant declaration, affirming the great truths of Christianity and announcing its exaltation; and so it remained for two centuries.

This art was still in part funerary, but no longer was it underground. Our knowledge of it is based mostly on sarcophagi, or stone coffins, some obviously carved and decorated by fine artists, others mere journeywork. Stories carved in relief on the sarcophagi usually tend to deal with miracles prophetic of future life: the Raising of Lazarus, the Healing of the Paralytic, the Raising of Jairus' Daughter, the Raising of the Widow's Son. Later, other stories conveying Christian teachings in general came to be used as motifs: scenes of the Baptism, the Crucifixion, and the like. Gradually the number increased, so that we find as many as twenty-six different themes depicted in the Church of San Apollinare Nuovo in Ravenna, dedicated in 512 A.D. It has been estimated that more than one hundred had been developed by that time, although no single building of the period contains anything like a complete cycle.

As we have noted, Christian art was enriched by Hellenistic influence during the centuries immediately following the reign of Constantine. Then, about the sixth century, a change took place. For example, in almost all instances, the conception of a bearded Christ, issuing perhaps from the Holy Land, gradually replaced the pagan youth, just as the concept of Christ the Teacher replaced that of Christ the Good Shepherd. Churches and shrines built on holy sites were decorated according to the events that had occurred there: at Bethlehem the Nativity, on the Jordan the Baptism, at Golgotha the Crucifixion, at Bethany the Ascension. These scenes in the life of Christ were pictured with no pretense of historical accuracy. In fact, such an attempt would have been foreign to prevailing attitudes, and would in part have defeated the purpose for which the pictures were intended: to teach the tenets of Christianity.

At this time, too, another source of Christian iconography came into being. Eager to see the places that He had made sacred, pilgrims began to go to the Holy Land not long after the time of Christ. In the sixth century or thereabouts, local enterprise began to turn out a variety of mementos for these pious travelers to carry home—small objects of gold or silver or lead, of clay or of the wax from the candles flickering before sacred places, each decorated with a depiction of the holy event that had taken place on the site where the talisman was sold. These representations are generally believed to have been based on the great creations of Constantinian and later artists, leavened with more humble concepts of local origin. Although generally too small and too roughly made to have much effect stylistically, they served to spread far and wide the manner of illustrating these favorite scenes as conceived in the Holy Land, and their influence is to be seen most strongly in the arts of the Eastern Mediterranean, especially Constantinople.

The iconography thus developed in the Holy Land, changed and altered at Constantinople, Ravenna, and Rome, became the basis of all art in Western Europe for many centuries. Under Charlemagne in particular, a revival of the traditions of previous centuries resulted in a so-called "encyclopedic art," filling the cathedrals of Europe, such as Chartres, with sculpture, painting, and stained glass showing figures and events from the Old and New Testaments and from the lives of the saints. In such monuments the old tradition was modified by local artistic ideas: for instance the Celtic, in which pat-

tern was the first consideration, and the Teutonic, where the main effort was toward realism. It was a didactic art, expressing the dogma of the Church, and during the eleventh and early twelfth centuries, in what is called the Romanesque, it achieved a severity of form that was to make it seem unattractive to some in later ages. Teutonic realism made itself especially felt in the succeeding Gothic era, and most of all in the splendor of illuminated manuscripts, where the artist faithfully portrayed his subject and added exquisite detail and ornamentation. In the thirteenth century a new gentleness warmed the rather cold scholasticism that had characterized this art. A greater desire to please became evident. Among other influences, the mystery plays enacted on the steps of the cathedrals introduced many tender qualities as well as homely touches from the daily lives of the people.

In this early art, sculpture, fresco, and mosaic were as integral a part of an architectural design as illumination was of a manuscript. All was conceived with this unity in mind. But in the Renaissance we find the beginning of an isolated form of creation —easel painting—that marked the ascendancy of the individual. At this point began both a proliferation of detail and an attempt at historical authenticity in representing the life of Christ. Gradually, the simpler doctrinal concepts were lost to sight, and the direct storytelling that left the beholder in no doubt about events or interpretations disappeared. In time, this tendency led to the individual artist's expressing himself as he pleased. And thus the great tradition of religious art was lost.

Of course, religious artists of marked merit continue to appear from time to time, but theirs is an art in which individuality and even caprice reign undisciplined by tradition. The spiritual attitude of the Western world today, reflecting as it does so many divergent viewpoints and patterns of belief, is no longer able to produce works of religious art that, like so many in this book, freshly and fervently express the unified faith of great masses of mankind.

In sum, the process of evolving a generally accepted portraiture of Christ and an iconography for the events of His life was a slow one. The illustrations in this book are the product of many decades of development—as much as sixteen centuries in some cases; of the interpretations of an inconceivable number of students of the Gospel story; and of the imagination and inspiration of what is, in the opinion of many, the greatest tradition of art that the world has ever seen. An attempt has been made in the pages that follow to present some of the great works that this tradition has produced.

The life of Christ as it has come down to us was recorded by the Evangelists Matthew, Mark, Luke, and John. These men knew Christ personally and wanted passionately to have the world know what they had seen and heard.

Some events in the story of Jesus occur in several Gospels, whereas others are found in only one. Thus a logical sequence of events, aside from the teachings, is a little difficult to establish. This was felt as early as the second century of the Christian era, and at that time Tatian composed what he called the *Diatessarion*, in which he gave a unified account of Christ's life by making a composite of appropriate verses from the several Gospels. Tatian's solution was not considered quite appropriate for use in the church, because there were many omissions in his text, and in the fourth century, Eusebius, Bishop of Caesarea, composed tables listing similar events in corresponding positions, and leaving blank spaces where an event did not occur in any of the four Gospels. This arrangement was found very satisfactory and is still in use. However, Eusebius' canon tables are of no help in presenting the life of Christ in a series of pictures with accompanying text, and so we have here returned to something like Tatian's approach.

Tatian's method is actually a very happy one for

such a book as this. Not all the events in Christ's life could be included; but even as early as the fifth century artists had developed the iconography of over one hundred different scenes, and so almost all the crucial episodes in that momentous story, as well as some of the miracles, are represented.

In a single set of illustrations for Christ's life, whether in a church or a book, the pictures are generally by a single artist or group of artists. Here the illustrations are all from periods not later than the Renaissance, but they are by various artists, from different countries, and in a great variety of media. The comments below are therefore intended at least to place the pictures in time and space.

THE ANNUNCIATION

[p. 25

This interpretation, a sculpture in relief by Andrea della Robbia or members of his school, has a charm of line and color that suits the subject admirably, the white glaze and rich enameled colors lending a joyful and unearthly radiance to the figures. The Archangel Gabriel offers lilies to the Virgin and shining rays of light point to the dove, the symbol of the Holy Ghost. The Virgin in this scene is sometimes shown dutifully engaged in spinning, or, as here, holding a book of sacred writings that she has been reading.

THE VISITATION

[p. 28

The late Gothic German artist Bartholomaeus Zeitblom painted Mary and Elizabeth in costumes of his day and represented their meeting with grace and simplicity. The picture suggests the moment of the *Magnificat*, with all the sweet humility and sense of God's glory manifest in Mary's face. Except for the white hood worn by Elizabeth, the difference in age of the two women seems not to be expressed in any way. This scene is usually presented as it is here, the story being told as directly as it was by the artists of the Holy Land on the mementos prepared for pilgrims.

JOURNEY TO BETHLEHEM

[p. 31

There was, of course, no snow in the Holy Land when Christ was born, but just as it has almost everywhere become associated with Christmas, so Pieter Bruegel introduced it as background when he set about painting the journey that Mary and Joseph made to Bethlehem to pay the tax. Although the theme is a prosaic one and is presented as such, the artist has carried it off with no loss of spiritual significance or serenity. In this detail, Mary appears as a peasant girl, a figure appealing and understandable to the artist's contemporaries in Flanders. The picture is an excellent illustration of the Teutonic realism that Western Europe added to Christian iconography. The subject was not represented in the art of early Christian times, but was a later development; however, Bruegel has borrowed the ox and the ass from traditional Nativity scenes.

THE NATIVITY

[p. 33

Although long the best-loved of all scenes from the life of Christ, the Nativity did not appear in Christian art before the middle of the fourth century. For a time, the sixth of January, the date on which we now celebrate the feast of the Adoration of the Shepherds and the Magi, was considered Christmas, but St. Augustine of Hippo and others were convinced that the twenty-fifth of December was Christ's natal day, and eventually it was generally accepted as such. Following the Near Eastern tradition, Botticelli has placed the Nativity in a shed, with the Christ child lying near the manger, and Mary in adoration before Him. Joseph is shown resting after the long journey from Nazareth. The ox and the ass, which are here so tenderly depicted, began to appear in the earliest representations of this scene, with the setting sometimes a cave and at other times a shed or stable. Botticelli has infused his painting (of which only the central section is shown here) with an incomparable feeling of purity and joy.

ANNUNCIATION TO THE SHEPHERDS

[p. 34

This stained-glass panel from the Cathedral of Chartres is a striking example of medieval art from a building rich in representations of events from the Testaments and the lives of the saints. The three shepherds wear garments of the Middle Ages and carry the usual crooks. Angels from above bring their glad tidings, and since the shepherds are natives of Palestine, the scene signifies the Annunciation to the Jewish people of the birth of the Christ child.

THE ADORATION OF THE SHEPHERDS

[p. 37

Schongauer, a German artist, has sheltered the Holy Family on a hillside in what appears to be a ruined stable. As in the stained glass of Chartres, the shepherds here signify the Jewish people come to adore. The ox and the ass, as in the Nativity, represent the adoration of the animal world, which is not mentioned in the four Gospels, but which was made familiar to the early Christians by the Gospel of Pseudo-Matthew. One of the Apocryphal works that is no longer accepted, this book was at one time much loved; it tells how "on the third day after the birth of Our Lord Jesus Christ, the most blessed Mary went forth out of the cave, and entering a stable, placed the child in the manger, and the ox and the ass adored him." Schongauer's contribution is one of supreme serenity and tenderness. The Virgin kneels before her child, and Joseph stands with folded hands in an ancient attitude of humility. Behind Joseph are two shepherds, one very youthful, and through the snow toil three more shepherds with their crooks. Painted in a northern land, the countryside is shown covered with snow.

THE ADORATION OF THE MAGI

[p. 38

The only account of the visit of the Magi in the Gospels, St. Matthew's, does not state the number of men who came from the East. But since three gifts are described, gold, frankincense, and myrrh, the number of Magi was at a very early period put at three, and their gifts were considered symbols— gold for Christ the King, frankincense for His Godhood, and myrrh for His Mortality. There is no exact record of the age of Jesus at the time of this visitation, but the edict of Herod ordering the slaughter of all male children under the age of two makes it evident that Jesus was then in His first or second year. In Gentile da Fabriano's painting the child Jesus appears to be two or thereabouts. We judge the Magi to be the first converts from paganism, since they did not return to Herod with word of where the Child might be found. Gentile shows them richly dressed, their entourage comparable to those of Oriental princes, and including horses, camels, and exotic creatures such as monkeys. In the Near East the Magi were at an early time differentiated in age, their years indicated in two of them by the length of beard, and in the youngest by his beardlessness. The use of kneeling figures in the composition derives from the old scenes of princes coming from afar to pay tribute to an emperor. The beautifully balanced composition of this very great painting (of which only the center section is shown here) allows for all the sumptuous detail; and the deeply religious feeling of the artist is effectively expressed in the adoring postures of the Magi as well as the beauty of the Holy Family.

THE FLIGHT INTO EGYPT

[p. 41

The unknown artist who created this enchanted group in polychromed sculpture was inspired by an apocryphal legend relating that at one time during the journey of the Holy Family angels bent the branches of a date palm so that Joseph might pluck the fruit to refresh Mary and the Child. The Gospel text says only that Joseph took Mary and the Christ child to Egypt to protect Him from Herod, but the legends with which this passage is usually em-

broidered are so charming that they still have great appeal, even though they are not part of doctrinal teaching. In this representation the Holy Family is dressed like humble pilgrims of the late Middle Ages, who visited shrines in fulfillment of vows. Joseph carries the type of water flask known even up to the present as a "pilgrim's flask," and Mary sits the donkey in a fashion still seen in the Near East.

SLAUGHTER OF THE INNOCENTS

[p. 42

As in the Journey to Bethlehem, Bruegel has painted the Slaughter against a wintry northern background. He has retained only one of the old traditions of this scene, the use of the sword, which was a Near Eastern concept dating from the fourth century; later, and particularly in southern France, the victims were represented as crushed. The early Christians were slow to represent this massacre, the first in a long history of martyrdoms. It is not pictured in the Catacombs, where the emphasis is rather on the life to come than on suffering in this world. At one time the subject was represented in a totally symbolic manner, but Bruegel, moved no doubt by events in contemporary Flanders, which was suffering under the yoke of Spain, painted a scene that was not unlike some of the abominations he and his countrymen had witnessed. It was often thus that traditional events were given new life and vitality.

PRESENTATION IN THE TEMPLE

[p. 45

With its characteristically Flemish brilliance and clarity, this painting disarms one in many ways. The great master Hans Memling elects to ignore such matters as time and place, and presents the Christ child not in a temple or synagogue, but in a Gothic church, with all those present dressed in the clothes of the artist's own period in Holland—even to the sabots. Aside from this, the event is rendered in details faithful to the Gospels, from Simeon receiving the Christ child in his arms to the doves carried in a wicker basket by Joseph.

CHRIST AMONG THE DOCTORS

[p. 48

When Mary and Joseph missed the young Jesus on the journey home from their annual Passover visit to Jerusalem, they hastened back to Jerusalem and found Him in the temple among the doctors, or learned men. Duccio, the great Italian artist, has set the event in an Italian loggia, where the scholars sit about Him in varying attitudes of thoughtfulness and astonishment. Mary and Joseph seem oblivious of all save the joy of finding Jesus. Essentially, the scene is just as related in the Gospel and is so represented from the sixth century on. Duccio has brought to the subject a simple human warmth. This is in marked contrast to the Byzantine manner, which was hieratic in composition, with the Christ child seated on a throne reached by a flight of stairs on each side, and also to the setting as carved on early Christian sarcophagi in Rome—a schoolroom, with switches in evidence—which conformed more to the Pseudo-Matthew Gospel.

THE BAPTISM

[p. 51

Veit Stoss's sixteenth-century interpretation in polychromed wood sculpture is essentially the same in compostion as pictures of the Baptism on the small mementos brought back from the Holy Land by pilgrims in the sixth century. Christ stands knee-deep in the Jordan. At left, John the Baptist, clothed in a camel's-hair robe, raises his hand in blessing, and at the right an angel reverently holds Christ's robe. In John's left hand is a book, perhaps intended here to suggest his statement that he has seen and can bear witness that "this is the Son of God."

THE TEMPTATION

[p. 52

Duccio's "Temptation of Christ," once a part of the great altarpiece of the Cathedral at Siena, and originally carried there in a triumphal procession, is now one of the outstanding masterpieces in American collections. Duccio has placed his central figures

against a more elaborate background than he generally used and has thereby achieved an effect of great dramatic power. He chose the moment described by St. Matthew when Satan takes Jesus onto a high mountain and shows him "all the kingdoms of the world, and the glory of them." In contrast to the conceptions of other artists, Duccio has made the mountain one of the dominant notes in his composition, using it to reinforce the sense of Christ rising above the powers of darkness. The "kingdoms of the world" are shown as typical castles of medieval Italy, and are idealized to symbolize worldly glory. For some reason the scene does not appear to have interested the early Christians, and it remained undeveloped until the art of a later period. Perhaps this gave Duccio the freedom to create so fresh and imposing a composition.

THE CALLING OF PETER AND ANDREW

[p. 55

Like his "The Temptation," Duccio's "Calling of Peter and Andrew" was a part of the *maestas* of the Cathedral of Siena. It is marked by the direct and simple composition characteristic of much of his work. Christ is on the shore of the Sea of Galilee; and Simon, called Peter, and Andrew are responding to His call. They stand in their small boat, Peter accepting at once, and Andrew pausing as he lifts the net full of fish. So wonderfully expressive is the painting that it hardly needs accompanying text. From the days of the Catacombs, Peter's short beard made him the most easily identifiable of all the Apostles. It is not known whether some early likeness or tradition lies behind this manner of representing him, but it is very old. Less well preserved than "The Temptation of Christ," this is nonetheless one of the world's great pictures.

THE MARRIAGE AT CANA

[p. 56

The miracle of changing the water into wine at the marriage at Cana was not only Christ's first

miracle but has always been a favorite story. The unknown Spanish-Flemish master has chosen the moment immediately after the miraculous change, just as the governor, seated on Christ's left, is commenting upon the excellence of the drink; and he has captured it with an exquisiteness of detail, a grace of line, and a richness of color that make this a masterpiece of its kind. The two servants, one of them offering a cup to the bride and groom, are traditional figures in this scene. In the immediate background are those of Christ's Apostles who "believed on him." Aloft are angels, and the figure of Moses holding the tablets of the Commandments. Among other symbols is the wine itself, associated with the sacrament of communion, and even the jars, whose number, varying from one to seven, had a mystical significance in the Middle Ages.

THE SERMON ON THE MOUNT

[p. 58

The naive, early fifteenth-century English miniaturist who illustrated this translation of meditations on the life of Christ has followed the traditional concept of Christ standing atop the highest level of a serried mount. Quaintly he has ranged the disciples in equal numbers on either side of the Master and added the figure of the author, St. Bonaventura. This showing of a saint of later times in a sacred context was not unusual in the Middle Ages. The miniaturist has also given St. Peter a halo adorned with a cross, apparently unaware that the cross traditionally identifies Christ and that saints or holy persons are indicated by a simple halo. The position of Christ reminds one of earlier pictures showing emperors raised on shields above their admiring subjects, but this painting is executed with quaint charm rather than the skill of an imperial workman.

THE RAISING OF THE DAUGHTER OF JAIRUS

[p. 63

With its rich colors glowing against a gold background, this eleventh-century mosaic in the cathe-

dral at Monreale in Sicily illustrates the splendor of Byzantine art. The sparkling mosaic proves a perfect medium for conveying the opulence of Jairus' dwelling place. At the right of the daughter of Jairus as she rises are grouped Jairus, the mother of the girl, and members of the household, and near Christ at the left are Peter, James, and John, the brother of James. The rich circumstances of this scene are in marked contrast to the humble surroundings of a similar miracle depicted on another wall in the cathedral—The Raising of the Widow's Son.

JESUS STILLS THE STORM
[p. 64

The unknown Romanesque artist who painted this miniature in an evangelary for the Abbess Hitde von Meschede has chosen the moment just preceding the awakening of Christ by an alarmed Apostle. The expression of deep peace on Christ's face is in marked contrast to the fear on the faces of the twelve Apostles. This subject did not appear in early Christian art but is a later development. The style here, an example of Romanesque, is a severe and highly simplified one as compared with the Gothic realism that was to dominate art in the next age. The conception is so vigorous and the execution so powerful that it is difficult to realize that this is a small illumination from a manuscript page. It might as easily have been a fresco on a cathedral wall.

MIRACLE OF THE TRIBUTE MONEY
[p. 67

Masaccio's "Miracle of the Tribute Money" is a fresh and powerful composition, famous not only for its solidity and sense of volume but also its august conception. Christ and His Apostles are shown at the gate of Capernaum, where they are required to pay the tax levied on all strangers. Naively trying to cover the entire sequence of events, the artist in the full fresco shows Peter at the extreme left getting the money from a fish's mouth and at the extreme

right paying the collector. The central section, reproduced here, is at once simple and grand.

THE HEALING OF THE LAME AND THE BLIND
[p. 68

In this scene of the healing at the Sea of Galilee, the Byzantine mosaicist has studiously grouped Christ and His disciples on the left and the throng of suppliants on the right. The two triangular groups meet with dramatic effect at the point where Christ's gesture of blessing answers the imploring gestures of the ailing. Behind the disciples a stylized hill with trees on it indicates mountainous country, and in the background on the right Pharisees debate Christ's act. In the foreground, the kneeling man leans on two short crutches of a kind once commonly used by the lame.

IN THE HOUSE OF MARY AND MARTHA
[p. 71

In this great Renaissance painting, Tintoretto places the scene in a typical sixteenth-century Italian setting. Although Mary sat at Jesus' feet and did not serve Him, He approved, and through the expression on Mary's face and the way they lean toward each other the artist has conveyed fully and clearly the sense of the story. This picture could not have been painted when artists were controlled by traditional formulas, and yet for all the individualism of its conception it sacrifices none of its religious import; the artist has painted what seems to be an everyday scene and yet created a picture that transcends it.

THE MULTIPLICATION OF THE LOAVES AND FISHES
[p. 73

In early Christian thought this miracle was symbolic of the Eucharist. In the Catacombs it was pictured with great simplicity, the loaves and fishes sometimes suggesting the whole miracle by them-

selves. In San Apollinare Nuovo at Ravenna a mosaic presents the scene with beautiful but severe Byzantine formalism, Christ standing in the center, with a disciple on either side, stretching out His hands to bless the bread and fish. This composition derives from pictures of an emperor surrounded by members of his court, and makes no attempt to narrate the episode as described in the Gospels. Later, as in the mosaic at Monreale in Sicily, it becomes a wonderfully dramatic scene, the multitude and the loaves and fishes being shown with graphic vividness and force.

THE RAISING OF LAZARUS

[p. 76

The sixteenth-century Byzantine artist, conforming to the Gospel of St. John, has here placed the Raising of Lazarus in a wild and hilly setting. According to the Gospel, Lazarus was buried in a cave, and the stone rolled away when Christ raised him from the dead. The stone here becomes the lid of a coffin, and Lazarus is shown wrapped in linen according to the Near Eastern manner of embalming the dead. Christ's hand is raised in the traditional gesture of authority. Mary and Martha kneel before Him with covered hands, signifying both worship and humility. The disciples on either side of Christ observe the miracle in awe, and the Jews who have come to comfort Mary and Martha stand in the background discussing it in amazement. One figure at the right is shielding his face with his robe, a natural reaction in the presence of a body four days dead. The first of Christ's miracles pictured in the Catacombs, it appears in the second-century Catacomb of Priscilla. The repeated reference to the Resurrection in this story accounts for its great popularity among early Christians.

THE ENTRY INTO JERUSALEM

[p. 79

Giotto's fresh and charming fresco in the Arena Chapel at Padua introduced a new approach to the painting of form, yet followed the centuries-old

conception of the subject, which is based on the Gospel according to St. John. The people spread palm branches before Christ as he enters the city on an ass, and in a simple and natural touch, which at a very early time became a part of the tradition of this subject, children climb a tree to watch Him. Echoing familiar pictures of the triumphal entry of an emperor into a city, Christ is shown riding with the right hand raised. While the emperor is the monocrator, He has become the cosmocrator; thus were old imperial compositions adapted to Christian use.

THE DRIVING OUT OF THE MONEY-CHANGERS

[p. 81

In El Greco's "Purification of the Temple," Christ, wielding a scourge or whip, has overturned the table of the money-changers. The temple is pictured in the architectural style of El Greco's time, but the garments worn by the figures are not so much the elaborate costumes of his day as drapes and folds designed to produce certain planes of light and rhythm in the composition and perhaps to suggest antiquity. The two disciples at the lower right (one of them apparently Peter), as well as the Jews in the background, appear to be intently discussing the action. El Greco has followed the medieval custom of introducing a parallel between the Old and New Testaments by including a mural of Adam and Eve being driven from Eden.

WASHING THE FEET OF THE DISCIPLES

[p. 85

This subject became popular as early as the fourth century and may be seen in the decoration of Roman sarcophagi of that period. However, the sixth-century Near Eastern concept, in which St. Peter holds his hand on his forehead in an Oriental gesture of humility, was more widely followed. The twelfth-century miniaturist reduced the scene to its simplest terms. Christ is shown with His halo adorned by

the cross and His waist "with the towel wherewith he was girded," as described by St. John. The figure at the left has the long beard characteristic of St. Paul, the artist apparently following the tradition of substituting him for Judas. St. Peter has white hair and the usual short, curly beard. Perhaps because the Gospels do not recount specifically the baptism of the Apostles, some early Christian writers attempted to interpret this washing of the feet as a baptismal scene, but the Christian church in the West attributed to it only the significance of a simple act demonstrating the virtue of humility.

THE LAST SUPPER
[pp. 86, 89

All that one can say at this late date about the great reputation of Leonardo's "The Last Supper" is that it is a response to a unique fusion of noble conception, dramatic intensity, range of types, and beauty of execution. Its setting is typically Renaissance—a long table in a spacious room in a palace, with a beautiful Italian landscape in the background. Equally of the high Renaissance is the composition with its combination of vigorous action and careful balance. And finally the moment chosen by the artist is that of maximum drama, Christ having just predicted that the hand of the one who would betray Him is on the table. But perhaps its most remarkable achievement is creating twelve utterly distinct characters and giving each an expression that we can accept as characteristic of him at such a moment. Actually this scene was not a particularly familiar one among the early Christians. When they wished to symbolize the communion, artists were more likely to use the Multiplication of the Loaves and Fishes or the Supper at Emmaus. When The Last Supper began to appear in the Near East, it was treated in an Oriental manner, with a semicircular table and figures reclining around it. The long table became characteristic during the Middle Ages in the West, and it is in this tradition that Leonardo made his painting.

The reproductions in this book, one of the entire picture and the other of Christ, Thomas and James the Great, were made from the remarkable restoration completed in 1954. The restoration indicates that Leonardo actually finished the fresco and reveals facial expressions and the play of hands as they have not been seen in many generations.

THE AGONY IN THE GARDEN
[p. 90

After prophesying Peter's denial, Christ went with the disciples into the Garden of Gethsemane on the Mount of Olives, and the sixteenth-century Limoges enameler here shows the three sleeping Apostles with Christ in the background. The continuous-narration form, which concentrates several successive incidents in one picture, is here used effectively: thus the angel who came to comfort Him is presenting to Christ the cup He has mentioned in His prayer, while at the right Judas is shown leading the multitude to the betrayal, fulfilling Christ's prediction that His betrayer is at hand. Enamel is a very hard and durable medium which can easily be cleaned and in which colors remain fast for centuries; it can thus often give us, as here, a far better idea of the original colors used by the artist than either paintings or frescoes.

THE KISS OF JUDAS
[p. 93

Giotto's fresco of the Kiss of Judas in the church at Assisi is a masterly study in tension and dramatic concentration. Partly through extraordinary lighting and partly through an arrangement of converging lines, attention is almost violently focused on the two central figures. Within this composition Giotto develops another even more irresistible concentration on the face of Christ by means of the halo and its rays, as shown in the detail reproduced here.

CHRIST SEIZED IN THE GARDEN
[p. 94

The Byzantine painter Basileos followed the Gos-

pels closely in making this miniature: Judas has betrayed Christ; the armed mob is seizing Him; and Peter, identified by his short beard, has cut off the ear of the high priest's servant. Although the gold background gives no indication of setting, the torches carried by some in the crowd vividly suggest the night and the mood of mob violence.

THE CROWNING WITH THORNS

[p. 99

Although a Renaissance easel picture, Titian's work retains the essential elements of the scene as painted in the Middle Ages — Christ mocked, robed in the imperial purple, crowned with thorns, and holding a reed in lieu of a golden sceptre. The Gospels describe only the crowning of thorns; the pressing down of the crown became a part of the tradition during the Middle Ages. The anguish of the smiting is emphasized in the crisscross pattern of reeds in the composition, and the mockery is driven home by the officer, dressed in all the elegance of the Renaissance, who kneels, presumably hailing Christ as King of the Jews.

THE ROAD TO CALVARY

[p. 101

Subscribing, like his master Titian, to the individualistic approach of the Renaissance, Tintoretto has painted the Road to Calvary in an entirely new manner, merging the several versions of the Gospels and choosing themes to suit his arresting double-diagonal composition. For example, he has Christ carrying His own cross, as described in St. John, and not Simon of Cyrene carrying it for Him (as in the other Evangelists); and he has the two malefactors carrying their crosses, as in St. Luke, a detail omitted by the other three Gospels. Thus he has made a composite version of the story, as Tatian did long ago in his *Diatessarion,* and as we have done here with the text of the Gospels. To the inspired combination of themes and the exciting composition the artist has added an unearthly lighting, with the result that his painting is one of the most dramatic in all art.

THE PIERCING OF CHRIST'S SIDE

[p. 103

In this fifteenth-century enamel, considered to be the greatest by any Limoges artist, Monvaerni has retained the traditional arrangement, Christ in the center and a thief on either side, while St. John is below, the Marys are to the left, and the soldiers to the right. The artist has adhered to St. John's account, but has put two successive episodes together, one of the sponge being raised to Christ's face and the other of the piercing of His side. As in all early Crucifixion scenes, Christ is made to seem rather aloof and, in contrast to the two thieves, to show little sign of suffering. Gothic realism is apparent not only in the costumes but also in the Jerusalem of the background, which appears as a Gothic city with pinnacles. In measuring the artist's achievement here, it must be remembered that enameling is a stubborn technique, the material often requiring a dozen firings in a kiln before completion.

THE CRUCIFIXION

[p. 105

The early Christians had no pictures of the Crucifixion, in part because it would no doubt have been dangerous for them. They therefore used only the symbol of the cross. But by the sixth century there was a fully developed iconography of this scene, with Christ shown on the cross, the thieves on either side, and various figures arranged below. In the first pictures of the Crucifixion, Christ was shown clothed in a long robe and with eyes open but with no expression of anguish. In later representations His eyes are closed and His head fallen to one side. In Gothic art only one nail is shown fastening His feet to the cross, thus giving His body the twisting line so favored by Gothic artists. All these variations are in accord with church doctrine, except that they tend to avoid the representation of great suffering. But Grünewald in "The Little Crucifixion" has exerted himself to represent the maximum agony of the Crucified One and the anguish of the three who loved Him most, the Virgin, Mary

Magdalene, and St. John. With harrowing detail, an excruciating angularity of line, and an unearthly tonality, he has created a work of tragic grandeur, one that contrasts sharply with the remote, stiff characterizations of the first artists who depicted the event.

THE DESCENT FROM THE CROSS

[p. 107

This scene does not appear in early Christian painting. When it did appear in later works, it was presented in a stiff composition that usually showed two ladders against the cross. Seventeenth-century mysticism introduced into the treatment of the subject a great tenderness and a dolorous beauty. In Rembrandt's painting, Joseph of Arimathea, a counsellor who was secretly a disciple of Christ, has brought fine linen for the burial. With the greatest reverence he and other disciples are lowering the sacred body from the cross. The tension of the moment is emphasized by the characteristically Rembrandtesque lighting centered on Christ and Joseph and secondarily on the swooning Mary, and the tragedy is reflected not only on every face but in the crumpled figure being lowered from the cross. Against a dark and dramatic background, Rembrandt suggests the Holy Land in only a few details of Oriental costume.

PILATE AND THE WATCH

[p. 108

The medieval miniaturist who illuminated the Psalter of Robert de Lisle has given us an incident from the Gospel that has rarely been pictured, namely Pilate sending a watch to guard the sepulchre of Christ. The miniaturist pictured Pilate in the dress of a medieval king and the watch in Gothic chain mail and with a blazon on the captain's shield. The picture is thus intended to recall the Crusaders, the artist's contemporaries who went to Jerusalem to seize and guard the Holy Sepulchre from infidels, as well as represent the watch set over the original sepulchre.

THE MARYS AT THE TOMB

[p. 111

Although all the Gospels give the essential elements of the story of the Resurrection, they do not agree on details, and this has led to many variations in renderings of the subject. The Resurrection itself is not described, and artists who painted it usually followed a composition that was a matter of dogma and in no way realistic. Others painted pictures that indicated that the Resurrection had already occurred; and this is the approach used here by Fra Angelico. He shows the empty tomb in an Italian garden, with an angel speaking to the holy women, telling them that He has risen. The frightened guards sent by Pilate are no longer visible. The painting is characteristic of Fra Angelico in the clear, simple terms and the graceful lines with which he tells the story.

NOLI ME TANGERE

[p. 113

Botticelli has set the "Touch me not" scene completely in his own time and place, the setting being a contemporary Florentine garden with high walls and cypress trees, and the costumes those of fifteenth-century Italians. Christ is dressed as a gardener carrying a hoe over His shoulder, a treatment resulting from the fact that St. John, whom Botticelli followed here, says that Mary Magdalene mistook Him for a gardener. St. John does not say that Mary Magdalene tried to touch Jesus but rather implies it. Both figures are created with the flowing grace of line that is the hallmark of Botticelli's art.

THE SUPPER AT EMMAUS

[p. 115

The incident of the two disciples at Emmaus is related only in the Gospel of St. Luke. Christ had manifested Himself first to Mary Magdalene in the garden, then to the Marys returning to the tomb, to Peter late in the afternoon, and after that to the two disciples on the road to Emmaus. These disciples did not at once recognize the risen Christ, but Jesus revealed Himself to them when He took the

bread and blessed it. Making effective use of the artificial light of an interior, Caravaggio not only focuses our attention on the three figures, and Christ in particular, but also creates a sense of the utter concentration of men who are being entrusted with a great revelation. Following a seventeenth-century tendency, Caravaggio has painted simple peasant types for all but Christ, and has only suggested that the scene is laid in Palestine by painting an Oriental rug on the table.

THE DOUBTING OF THOMAS
[p. 118

A leaf from a manuscript illuminated at Limoges late in the twelfth century here strikingly interprets the episode that takes place when Thomas says that he will not believe until he can thrust his hand into Jesus' side. The miniaturist, trained in the same school as the enamelers and stained-glass makers who decorated the medieval churches of France, illustrates the words literally but with such freshness and naiveté that one has no feeling of revulsion.

CHRIST AT THE SEA OF GALILEE
[p. 123

Of all the paintings of this scene of Our Lord after the Resurrection, Tintoretto's conveys a maximum

sense of His majesty. It resembles representations of such earlier episodes as Christ Calling the Apostles and Christ Saving Peter from the Waters, but it goes further in depicting Him in His full Godhood and complete dominion over the elements of sea and air. And in Peter, who has girt his coat about him and thrown himself into the sea, it attests the triumph, at last, of faith.

THE ASCENSION
[p. 124

The miniature of the Ascension from a Florentine manuscript of the fourteenth century has kept to the naive form of treatment typical of the sixth-century keepsakes brought back from the Holy Land by pilgrims. The only difference is in the materials, for here there is the brilliant color and luminous gold leaf of a lovingly illuminated manuscript. The traditional composition is unchanged: Christ is shown in a mandorla, seated on the Arc of Heaven and with His hand raised in blessing in a gesture reminiscent of imperial Roman figures. Below Him is the Virgin with her hands composed in the Oriental attitude of prayer. On either side of her stand the Apostles saluting Him with a gesture resembling the one used by the populace in acclaiming an emperor.

The Life of Christ

IN MASTERPIECES OF ART

I. The angel Gabriel appears to Mary and tells her of the son she will bear

ST. LUKE I, verses 26 to 38

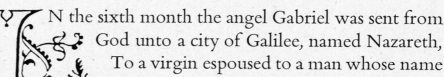IN the sixth month the angel Gabriel was sent from God unto a city of Galilee, named Nazareth,

To a virgin espoused to a man whose name was Joseph, of the house of David; and the virgin's name was Mary.

And the angel came in unto her, and said, Hail, thou that art highly favoured, the Lord is with thee: blessed art thou among women.

And when she saw him, she was troubled at his saying, and cast in her mind what manner of salutation this should be.

And the angel said unto her, Fear not, Mary: for thou hast found favour with God.

And, behold, thou shalt conceive in thy womb, and bring forth

The Annunciation

ANDREA DELLA ROBBIA (1435–1525?)

Pinacoteca Comunale, Città di Castello

a son, and shalt call his name JESUS.

He shall be great, and shall be called the Son of the Highest: and the Lord God shall give unto him the throne of his father David:

And he shall reign over the house of Jacob for ever; and of his kingdom there shall be no end.

Then said Mary unto the angel, How shall this be, seeing I know not a man?

And the angel answered and said unto her, The Holy Ghost shall come upon thee, and the power of the Highest shall overshadow thee: therefore also that holy thing which shall be born of thee shall be called the Son of God.

And, behold, thy cousin Elizabeth, she hath also conceived a son in her old age: and this is the sixth month with her, who was called barren.

For with God nothing shall be impossible.

And Mary said, Behold the handmaid of the Lord: be it unto me according to thy word. And the angel departed from her.

II. Mary visits Elizabeth, who salutes her as blessed among women

ST. LUKE I, verses 39 to 56

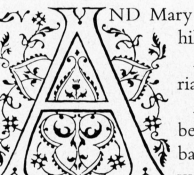AND Mary arose in those days, and went into the hill country with haste, into a city of Juda;

And entered into the house of Zacharias, and saluted Elizabeth.

And it came to pass, that, when Elizabeth heard the salutation of Mary, the babe leaped in her womb; and Elizabeth was filled with the Holy Ghost:

And she spoke out with a loud voice, and said, Blessed art thou among women, and blessed is the fruit of thy womb.

And whence is this to me, that the mother of my Lord should come to me?

For, lo, as soon as the voice of thy salutation sounded in mine ears, the babe leaped in my womb for joy.

And blessed is she that believed: for there shall be a performance of those things which were told her from the Lord.

[Mary visits Elizabeth, who salutes her as blessed among women]

And Mary said, My soul doth magnify the Lord,

And my spirit hath rejoiced in God my Saviour.

For he hath regarded the low estate of his handmaiden: for, behold, from henceforth all generations shall call me blessed.

For he that is mighty hath done to me great things; and holy is his name.

And his mercy is on them that fear him from generation to generation.

He hath showed strength with his arm; he hath scattered the proud in the imagination of their hearts.

He hath put down the mighty from their seats, and exalted them of low degree.

He hath filled the hungry with good things; and the rich he hath sent empty away.

He hath helped his servant Israel, in remembrance of his mercy;

As he spoke to our fathers, to Abraham, and to his seed for ever.

And Mary abode with her about three months, and returned to her own house.

The Visitation

BARTHOLOMAEUS ZEITBLOM (ca. 1450–1521)

The Fogg Museum of Art,

Harvard University

III. Joseph and Mary journey to Bethlehem for the taxing

ST. LUKE II, verses 1 to 5

IT came to pass in those days that there went out a decree from Caesar Augustus that all the world should be taxed.

(And this taxing was first made when Cyrenius was governor of Syria.)

And all went to be taxed, every one into his own city.

And Joseph also went up from Galilee, out of the city of Nazareth, into Judæa, unto the city of David, which is called Bethlehem (because he was of the house and lineage of David):

To be taxed with Mary his espoused wife, being great with child.

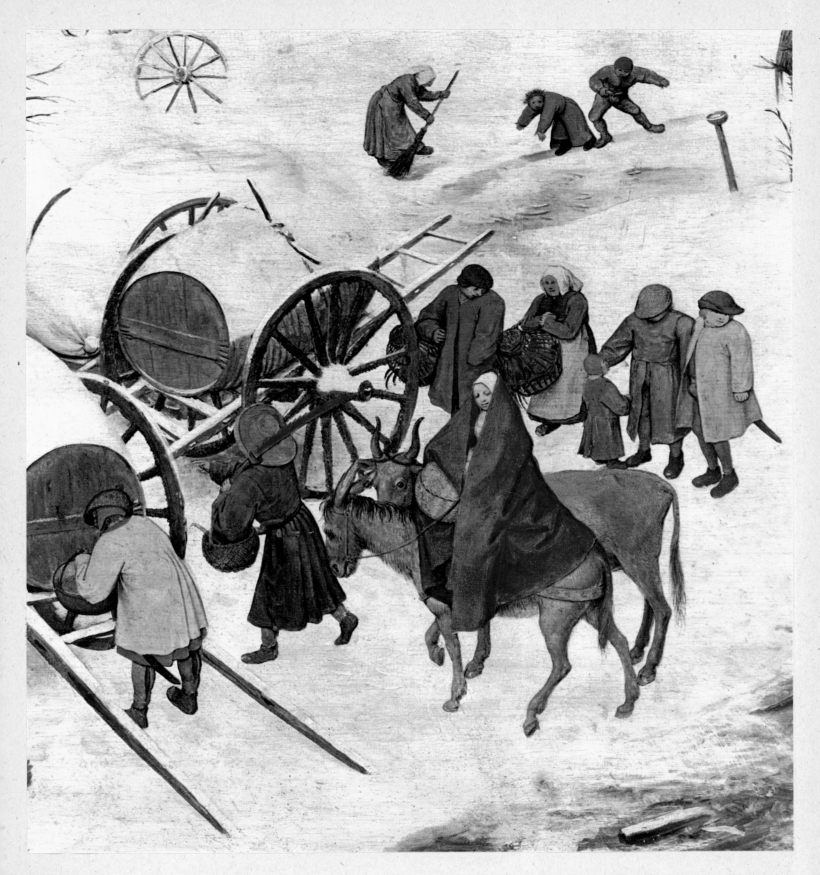

The Census in Bethlehem (detail)

PIETER BRUEGEL THE ELDER *(ca. 1525/30–1569)*

Musée Royal des Beaux-Arts, Brussels

IV. In Bethlehem the Christ child is born

ST. LUKE II, verses 6 to 7

ND so it was that, while they were there, the days were accomplished that she should be delivered.

And she brought forth her first-born son, and wrapped him in swaddling clothes, and laid him in a manger; because there was no room for them in the inn.

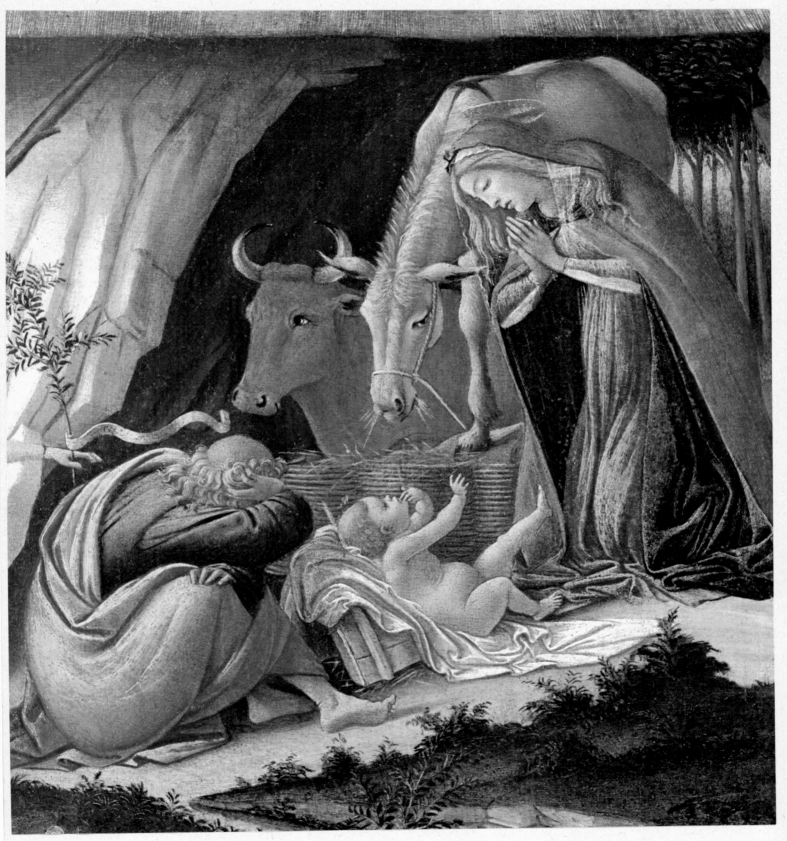

The Nativity (detail)

BOTTICELLI (1444/45–1510)

National Gallery, London

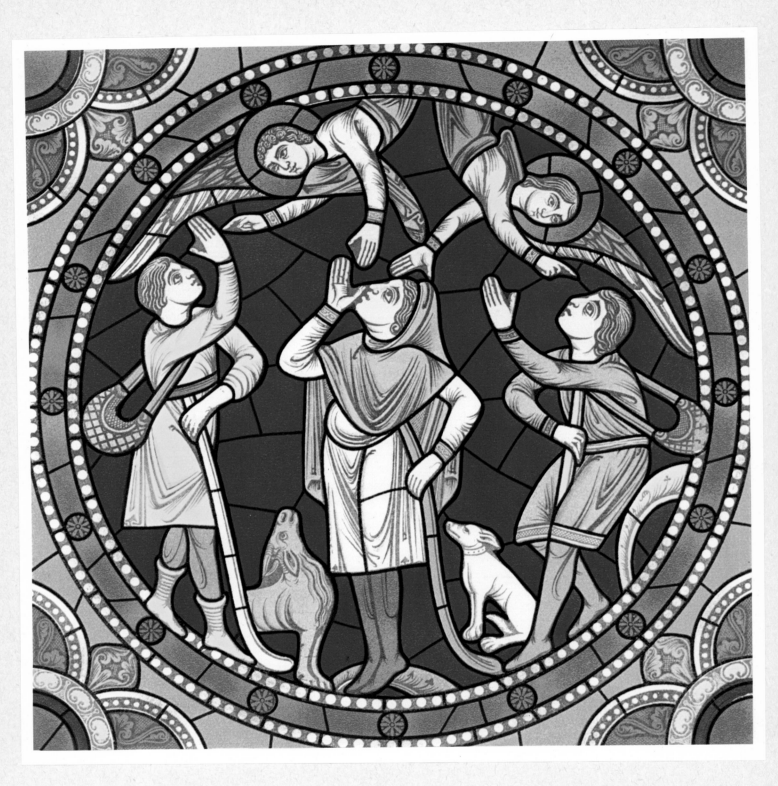

The Angels Appear to the Shepherds
STAINED GLASS (*12th century*)
Cathedral at Chartres

V. An angel brings to the shepherds tidings of the birth of a Saviour

ST. LUKE II, verses 8 to 14

HERE were in the same country shepherds abiding in the field, keeping watch over their flock by night.

And, lo, the angel of the Lord came upon them, and the glory of the Lord shone round about them: and they were sore afraid.

And the angel said unto them, Fear not: for, behold, I bring you good tidings of great joy, which shall be to all people.

For unto you is born this day in the city of David a Saviour, which is Christ the Lord.

And this shall be a sign unto you; Ye shall find the babe wrapped in swaddling clothes, lying in a manger.

And suddenly there was with the angel a multitude of the heavenly host praising God, and saying,

Glory to God in the highest, and on earth peace, good will toward men.

VI. The shepherds hasten to the manger

ST. LUKE II, verses 15 to 20

IT came to pass, as the angels were gone away from them into heaven, the shepherds said one to another, Let us now go even unto Bethlehem, and see this thing which is come to pass, which the Lord hath made known unto us.

And they came with haste, and found Mary, and Joseph, and the babe lying in a manger.

And when they had seen it, they made known abroad the saying which was told them concerning this child.

And all they that heard it wondered at those things which were told them by the shepherds.

But Mary kept all these things, and pondered them in her heart.

And the shepherds returned, glorifying and praising God for all the things that they had heard and seen, as it was told unto them.

Adoration of the Shepherds

MARTIN SCHONGAUER (ca. 1430–1491)

Stadelsches Kunstinstitut, Frankfor

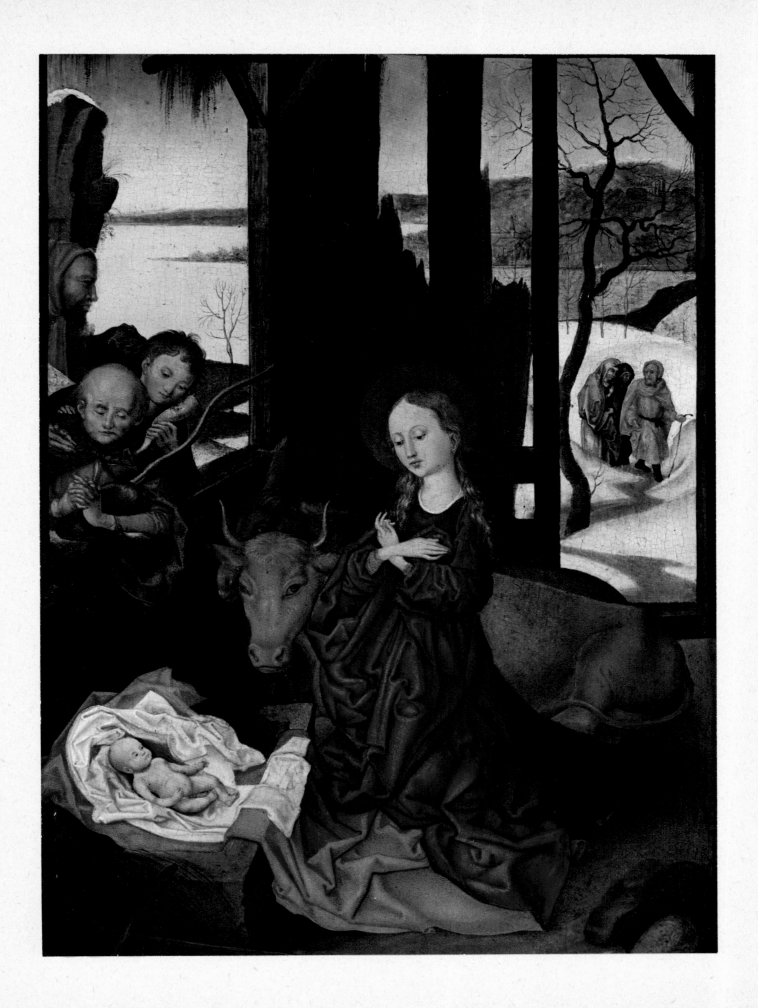

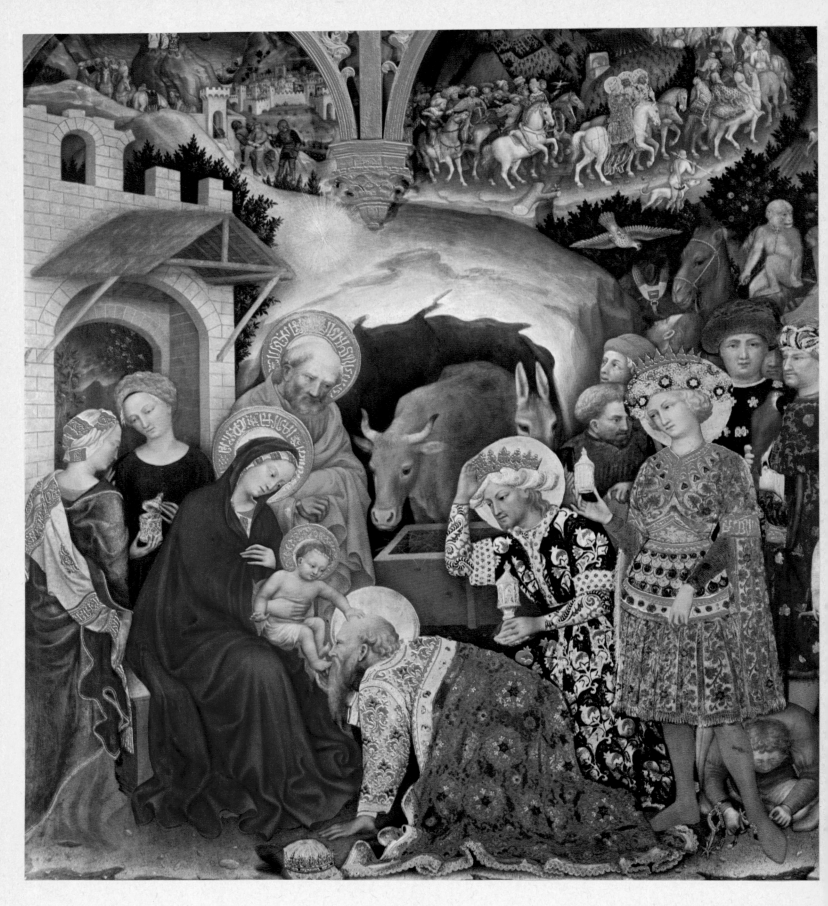

Adoration of the Magi (detail)

GENTILE DA FABRIANO *(ca. 1370–1427)*

Galleria degli Uffizi, Florence

VII. Wise men, coming from the East, bring the child gifts

ST. MATTHEW II, verses 1 to 12

NOW when Jesus was born in Bethlehem of Judæa in the days of Herod the king, behold, there came wise men from the east to Jerusalem,

Saying, Where is he that is born King of the Jews? for we have seen his star in the east, and are come to worship him.

When Herod the king had heard these things, he was troubled, and all Jerusalem with him.

And when he had gathered all the chief priests and scribes of the people together, he demanded of them where Christ should be born.

And they said unto him, In Bethlehem of Judæa: for thus it is written by the prophet.

And thou Bethlehem, in the land of Juda, art not the least among the princes of Juda: for out of thee shall come a Governor, that shall rule my people Israel.

Then Herod, when he had privily called the wise men, enquired of them diligently what time the star appeared.

And he sent them to Bethlehem, and said, Go and search diligently for the young child; and when ye have found him, bring me word again, that I may come and worship him also.

When they had heard the king, they departed; and, lo, the star, which they saw in the east, went before them, till it came and stood over where the young child was.

When they saw the star, they rejoiced with exceeding great joy.

And when they were come into the house, they saw the young child with Mary his mother, and fell down, and worshipped him: and when they had opened their treasures, they presented unto him gifts; gold, and frankincense, and myrrh.

And being warned of God in a dream that they should not return to Herod, they departed into their own country another way.

VIII. Warned against Herod, Joseph flees into Egypt with Mary and the child

ST. MATTHEW II, verses 13 to 15

AND when they were departed, behold, the angel of the Lord appeareth to Joseph in a dream, saying, Arise, and take the young child and his mother, and flee into Egypt, and be thou there until I bring thee word: for Herod will seek the young child to destroy him.

When he arose, he took the young child and his mother by night, and departed into Egypt:

And was there until the death of Herod: that it might be fulfilled which was spoken of the Lord by the prophet, saying, Out of Egypt have I called my son.

The Flight into Egypt

PAINTED AND GILDED RELIEF

(Spanish, late 15th century

Metropolitan Museum of Art, New York

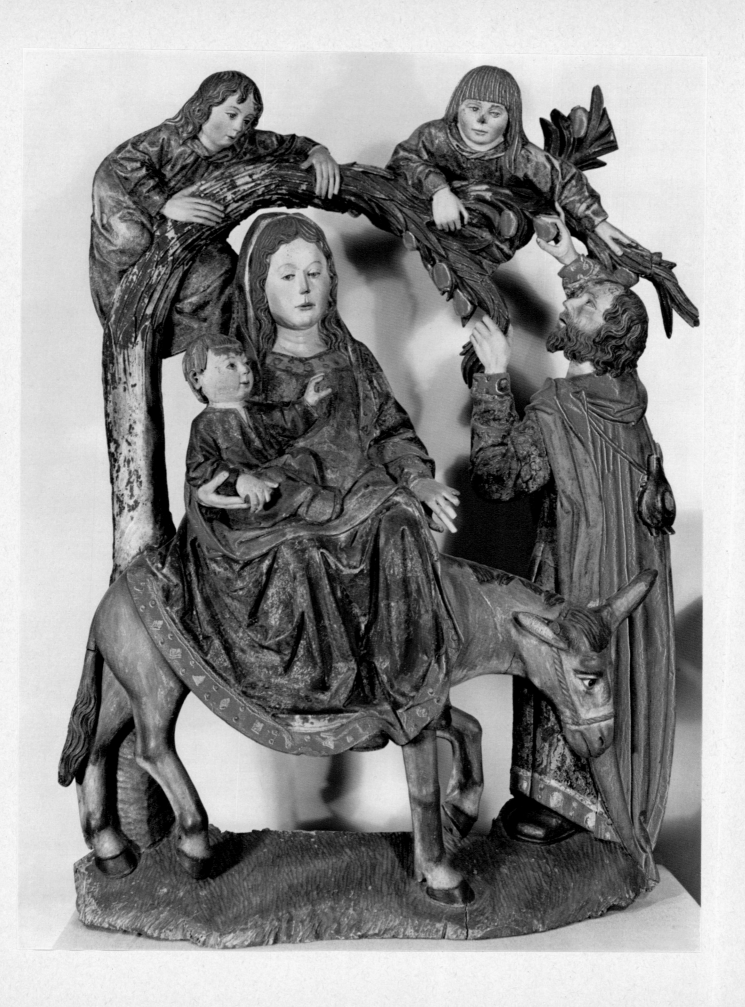

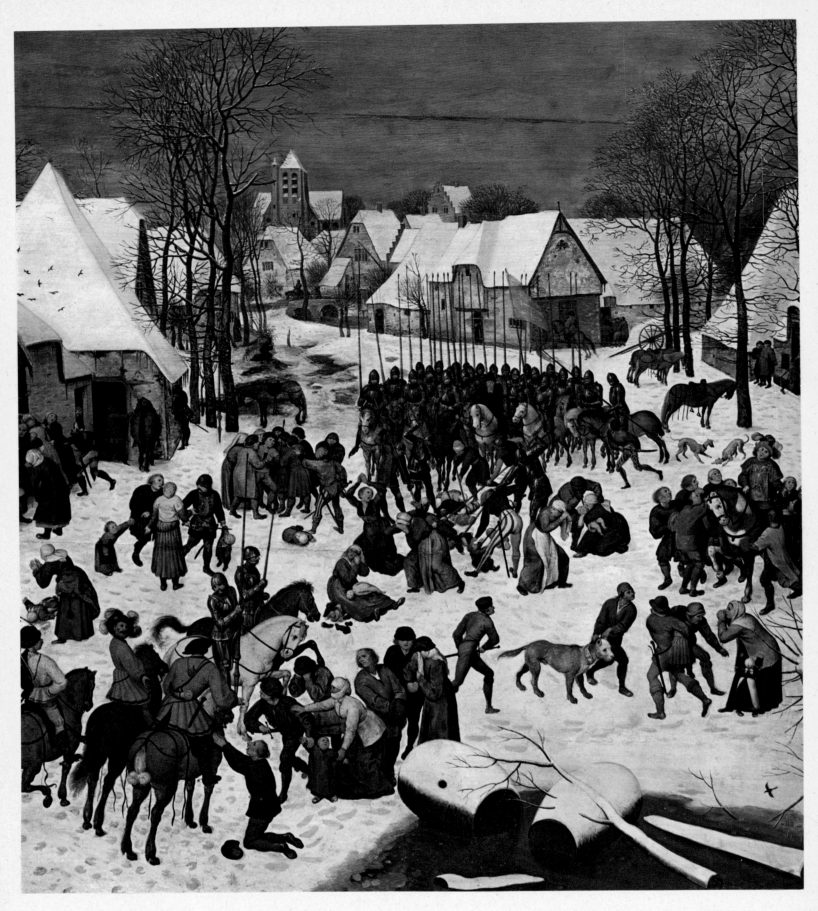

Massacre of the Innocents (detail)

PIETER BRUEGEL THE ELDER (*ca. 1525/30–1569*)

Kunsthistorisches Museum, Vienna

IX. The children of Bethlehem are put to the sword

ST. MATTHEW II, verses 16 to 23

THEN Herod, when he saw that he was mocked of the wise men, was exceeding wroth, and sent forth, and slew all the children that were in Bethlehem, and in all the coasts thereof, from two years old and under, according to the time which he had diligently enquired of the wise men.

Then was fulfilled that which was spoken by Jeremy the prophet, saying,

In Rama was there a voice heard, lamentation, and weeping, and great mourning, Rachel weeping for her children, and would not be comforted, because they are not.

But when Herod was dead, behold, an angel of the Lord appeareth in a dream to Joseph in Egypt,

Saying, Arise, and take the young child and his mother, and go into the land of Israel: for they are dead which sought the young child's life.

And he arose, and took the young child and his mother, and came into the land of Israel.

But when he heard that Archelaus did reign in Judæa in the room of his father Herod, he was afraid to go thither: notwithstanding, being warned of God in a dream, he turned aside into the parts of Galilee:

And he came and dwelt in a city called Nazareth: that it might be fulfilled which was spoken by the prophets, He shall be called a Nazarene.

X. Mary and Joseph bring the child into the temple to present Him to the Lord

ST. LUKE II, verses 21 to 40

AND when eight days were accomplished for the circumcising of the child, his name was called JESUS, which was so named of the angel before he was conceived in the womb.

And when the days of her purification according to the law of Moses were accomplished, they brought him to Jerusalem, to present him to the Lord;

(As it is written in the law of the Lord, Every male that openeth the womb shall be called holy to the Lord);

And to offer a sacrifice according to that which is said in the law of the Lord, A pair of turtledoves, or two young pigeons.

And, behold, there was a man in Jerusalem, whose name was Simeon; and the same man was just and devout, waiting for the consolation of Israel: and the Holy Ghost was upon him.

And it was revealed unto him by the Holy Ghost that he should not see death before he had seen the Lord's Christ.

And he came by the Spirit into the temple: and when the parents brought in the child Jesus, to do for him after the custom of the law,

Presentation in the Temple

HANS MEMLING (ca. 1435–1494

Kress Collection, National Gallery of Art

Washington, D.C

44

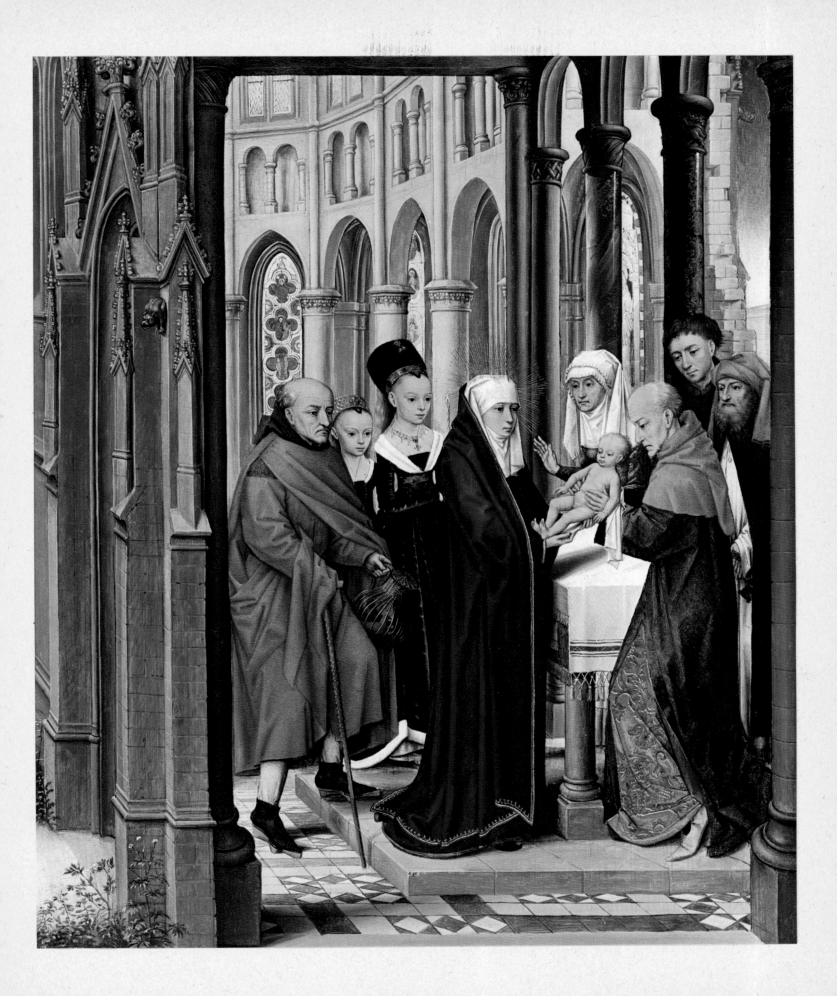

Then took he him up in his arms, and blessed God, and said,

Lord, now lettest thou thy servant depart in peace, according to thy word:

For mine eyes have seen thy salvation,

Which thou hast prepared before the face of all people;

A light to lighten the Gentiles, and the glory of thy people Israel.

And Joseph and his mother marvelled at those things which were spoken of him.

And Simeon blessed them, and said unto Mary his mother, Behold, this child is set for the fall and rising again of many in Israel; and for a sign which shall be spoken against;

(Yea, a sword shall pierce through thy own soul also) that the thoughts of many hearts may be revealed.

And there was one Anna, a prophetess, the daughter of Phanuel, of the tribe of Aser: she was of great age, and had lived with a husband seven years from her virginity;

And she was a widow of about fourscore and four years, which departed not from the temple, but served God with fastings and prayers night and day.

And she coming in that instant gave thanks likewise unto the Lord, and spoke of him to all them that looked for redemption in Jerusalem.

And when they had performed all things according to the law of the Lord, they returned into Galilee, to their own city Nazareth.

And the child grew, and waxed strong in spirit, filled with wisdom: and the grace of God was upon him.

XI. The child Jesus sits among the doctors in the temple

ST. LUKE II, verses 41 to 52

NOW his parents went to Jerusalem every year at the feast of the Passover.

And when he was twelve years old, they went up to Jerusalem after the custom of the feast.

And when they had fulfilled the days, as they returned, the child Jesus tarried behind in Jerusalem; and Joseph and his mother knew not of it.

But they, supposing him to have been in the company, went a day's journey; and they sought him among their kinsfolk and acquaintance.

And when they found him not, they turned back again to Jerusalem, seeking him.

And it came to pass that after three days they found him in the temple, sitting in the midst of the doctors, both hearing them, and asking them questions.

And all that heard him were astonished at his understanding and answers.

And when they saw him, they were amazed: and his mother said unto him, Son, why hast thou thus dealt with us? Behold, thy father and I have sought thee sorrowing.

And he said unto them, How is it that ye sought me? wist ye not that I must be about my Father's business?

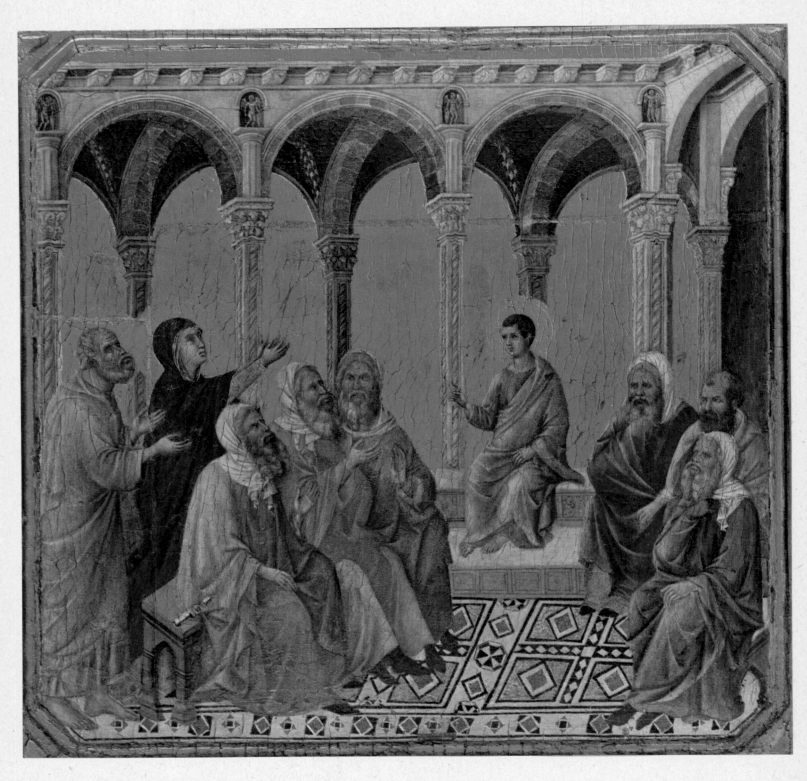

The Child Jesus in the Temple

DUCCIO *(ca. 1255–1319)*

Museo Opera del Duomo, Siena

And they understood not the saying which he spoke unto them.

And he went down with them, and came to Nazareth, and was subject unto them: but his mother kept all these sayings in her heart.

And Jesus increased in wisdom and stature, and in favour with God and man.

XII. John the Baptist preaches that the kingdom of heaven is at hand; and Jesus is baptized by him

ST. MATTHEW III, verses 1 to 17

IN those days came John the Baptist, preaching in the wilderness of Judæa,

And saying, Repent ye: for the kingdom of heaven is at hand.

For this is he that was spoken of by the prophet Esaias, saying, The voice of one crying in the wilderness, Prepare ye the way of the Lord, make his paths straight.

And the same John had his raiment of camel's hair, and a leathern girdle about his loins; and his meat was locusts and wild honey.

Then went out to him Jerusalem, and all Judæa, and all the region round about Jordan,

[John the Baptist preaches that the kingdom of heaven is at hand; and Jesus is baptized by him]

And were baptized of him in Jordan, confessing their sins.

But when he saw many of the Pharisees and Sadducees come to his baptism, he said unto them, O generation of vipers, who hath warned you to flee from the wrath to come?

Bring forth therefore fruits meet for repentance:

And think not to say within yourselves, We have Abraham to our father: for I say unto you that God is able of these stones to raise up children unto Abraham.

And now also the axe is laid unto the root of the trees: therefore every tree which bringeth not forth good fruit is hewn down, and cast into the fire.

I indeed baptize you with water unto repentance: but he that cometh after me is mightier than I, whose shoes I am not worthy to bear: he shall baptize you with the Holy Ghost, and with fire:

Whose fan is in his hand, and he will thoroughly purge his floor, and gather his wheat into the garner; but he will burn up the chaff with unquenchable fire.

Then cometh Jesus from Galilee to Jordan unto John, to be baptized of him.

But John forbad him, saying, I have need to be baptized of thee, and comest thou to me?

And Jesus answering said unto him, Suffer it to be so now: for thus it becometh us to fulfil all righteousness. Then he suffered him.

And Jesus, when he was baptized, went up straightway out of the water: and, lo, the heavens were opened unto him, and he saw the Spirit of God descending like a dove, and lighting upon him:

And lo a voice from heaven, saying, This is my beloved Son, in whom I am well pleased.

The Baptist

VEIT STOSS (late 15th century)

Polychromed and gilded wood, from an altarpiece at Cracow

Metropolitan Museum of Art, New York

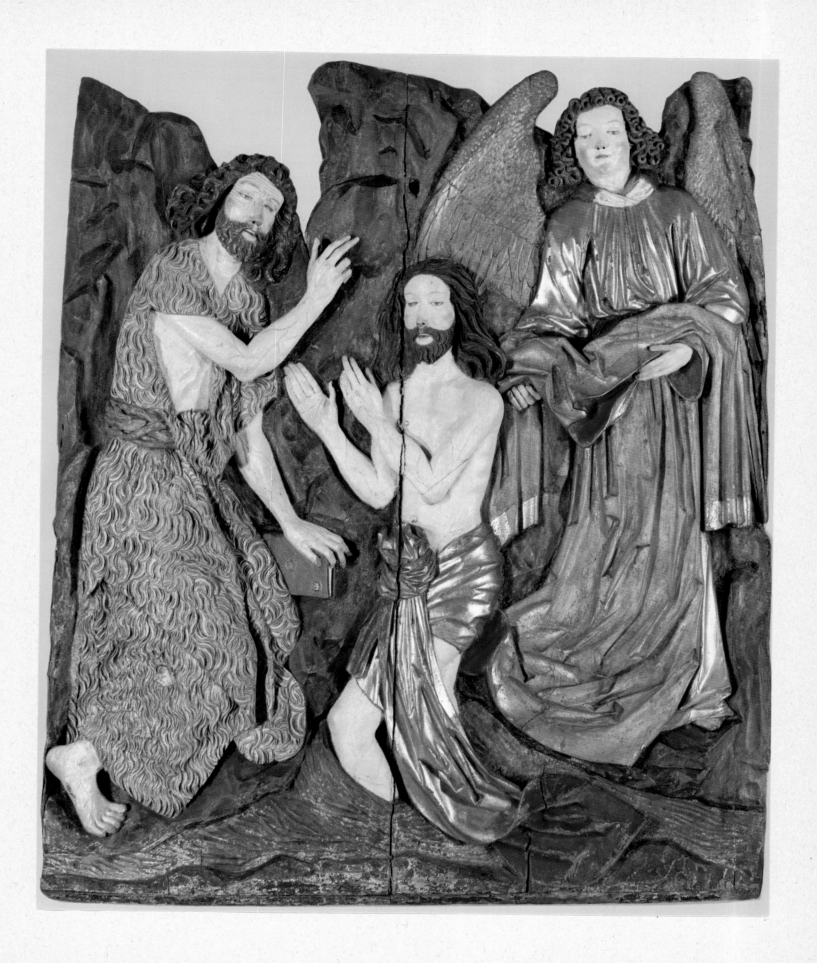

XIII. In the wilderness, Jesus is tempted by the devil

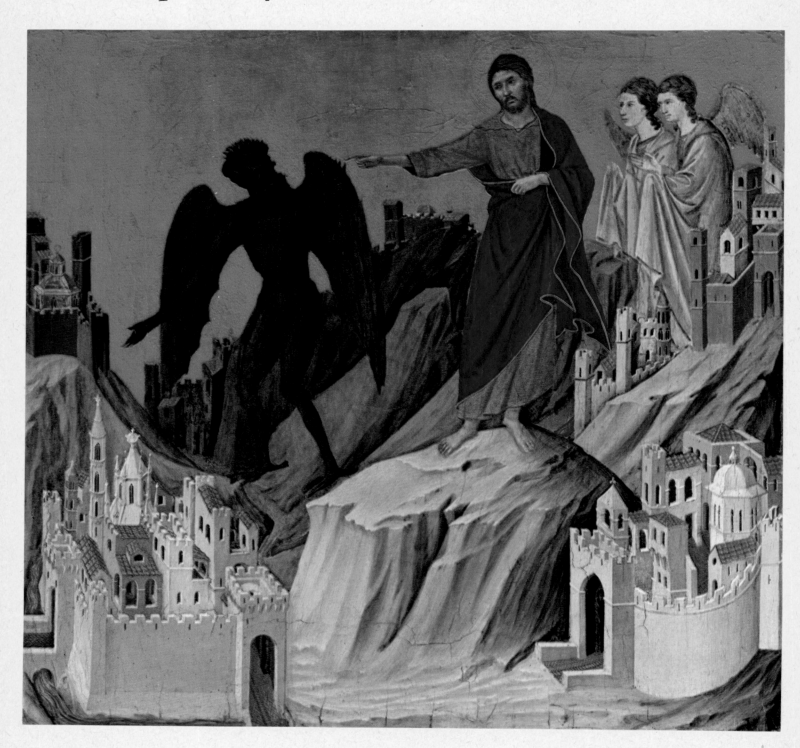

The Temptation of Christ

DUCCIO (*ca. 1255–1319*)

The Frick Collection, New York

ST. MATTHEW IV, verses 1 to 11

THEN was Jesus led up of the spirit into the wilderness to be tempted of the devil.

And when he had fasted forty days and forty nights, he was afterward ahungered.

And when the tempter came to him, he said, If thou be the Son of God, command that these stones be made bread.

But he answered and said, It is written, Man shall not live by bread alone, but by every word that proceedeth out of the mouth of God.

Then the devil taketh him up into the holy city, and setteth him on a pinnacle of the temple,

And saith unto him, If thou be the Son of God, cast thyself down: for it is written, He shall give his angels charge concerning thee: and in their hands they shall bear thee up, lest at any time thou dash thy foot against a stone.

Jesus said unto him, It is written again, Thou shalt not tempt the Lord thy God.

Again, the devil taketh him up into an exceeding high mountain, and showeth him all the kingdoms of the world, and the glory of them;

And saith unto him, All these things will I give thee, if thou wilt fall down and worship me.

Then saith Jesus unto him, Get thee hence, Satan, for it is written, Thou shalt worship the Lord thy God, and him only shalt thou serve.

Then the devil leaveth him, and, behold, angels came and ministered unto him.

XIV. Jesus tells the fishermen to leave their nets and follow Him, saying, I will make you fishers of men

ST. MATTHEW IV, verses 18 to 25

JESUS, walking by the sea of Galilee, saw two brethren, Simon called Peter, and Andrew his brother, casting a net into the sea: for they were fishers.

And he saith unto them, Follow me, and I will make you fishers of men.

And they straightway left their nets, and followed him.

And going on from thence, he saw other two brethren, James the son of Zebedee, and John his brother, in a ship with Zebedee their father, mending their nets; and he called them.

And they immediately left the ship and their father, and followed him.

And Jesus went about all Galilee, teaching in their synagogues, and preaching the gospel of the kingdom, and healing all manner of sickness and all manner of disease among the people.

And his fame went throughout all Syria: and they brought unto him all sick people that were taken with divers diseases and torments, and those which were possessed with devils, and those which were lunatic, and those that had the palsy; and he healed them.

And there followed him great multitudes of people from Galilee, and from Decapolis, and from Jerusalem, and from Judæa, and from beyond Jordan.

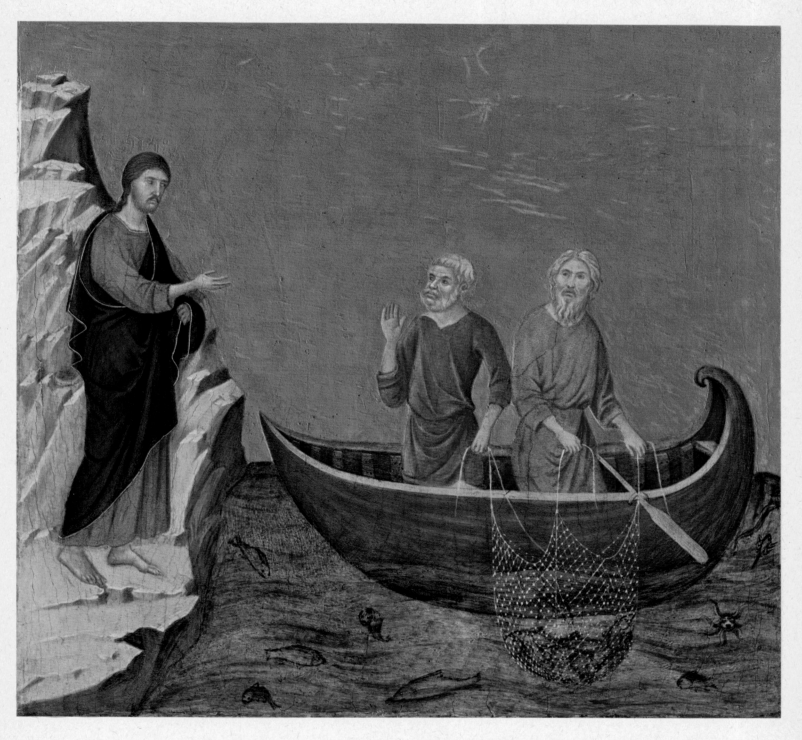

Calling of the Apostles Peter and Andrew

DUCCIO (*ca. 1255–1319*)

Kress Collection, National Gallery of Art,

Washington, D.C.

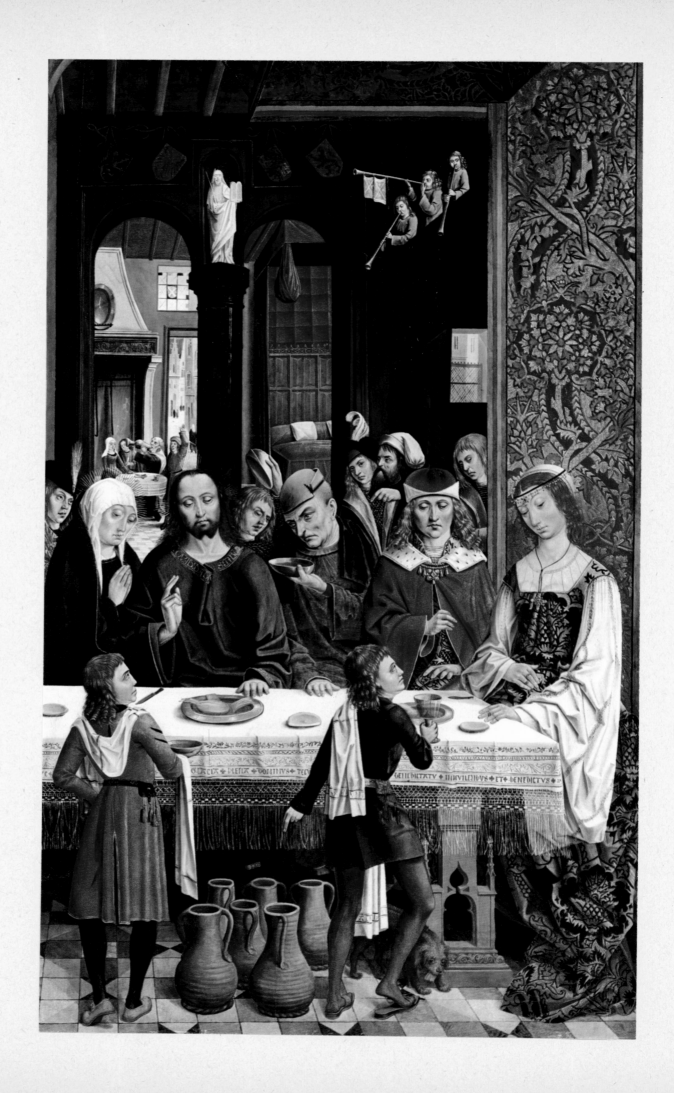

XV. Jesus is called to a marriage at Cana, and of the water He makes wine

ST. JOHN II, verses 1 to 11

ND the third day there was a marriage in Cana of Galilee; and the mother of Jesus was there:

And both Jesus was called, and his disciples, to the marriage.

And when they wanted wine, the mother of Jesus saith unto him, They have no wine.

Jesus saith unto her, Woman, what have I to do with thee? mine hour is not yet come.

His mother saith unto the servants, Whatsoever he saith unto you, do it.

And there were set there six waterpots of stone, after the manner of the purifying of the Jews, containing two or three firkins apiece.

Jesus saith unto them, Fill the waterpots with water. And they filled them up to the brim.

And he saith unto them, Draw out now, and bear unto the governor of the feast. And they bore it.

When the ruler of the feast had tasted the water that was made

The Marriage at Cana

Master of the retable of the Reyes Católicos

(Spanish-Flemish, late 15th century)

Kress Collection, National Gallery of Art,

Washington, D.C.

wine, and knew not whence it was (but the servants which drew the water knew), the governor of the feast called the bridegroom,

And saith unto him, Every man at the beginning doth set forth good wine; and when men have well drunk, then that which is worse: but thou hast kept the good wine until now.

This beginning of miracles did Jesus in Cana of Galilee, and manifested forth his glory; and his disciples believed on him.

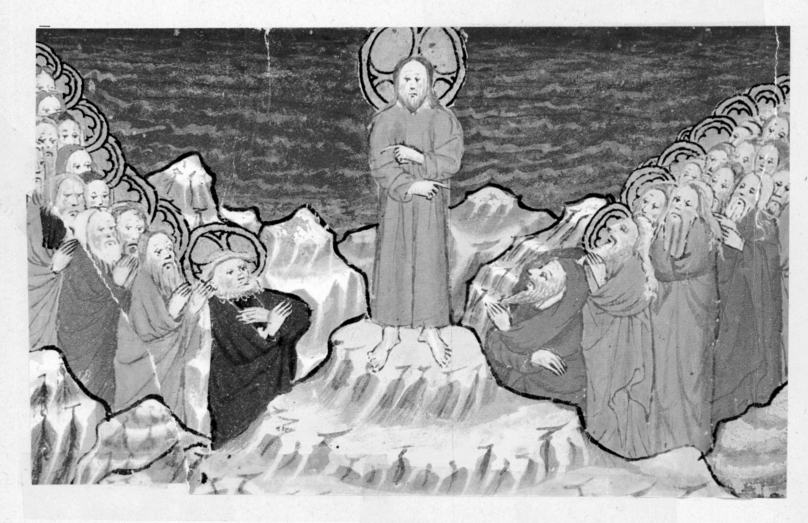

The Sermon on the Mount

ILLUMINATION *in an English translation (ca. 1400)*

of a Meditationes Vitae Christi *attributed to Bonaventura*

The Morgan Library, New York

XVI. From a mount, Jesus speaks to His followers

ST. MATTHEW V, verses 1 to 20

SEEING the multitudes, he went up into a mountain: and when he was set, his disciples came unto him:

And he opened his mouth, and taught them, saying,

Blessed are the poor in spirit: for theirs is the kingdom of heaven.

Blessed are they that mourn: for they shall be comforted.

Blessed are the meek: for they shall inherit the earth.

Blessed are they which do hunger and thirst after righteousness: for they shall be filled.

Blessed are the merciful: for they shall obtain mercy.

Blessed are the pure in heart: for they shall see God.

Blessed are the peacemakers: for they shall be called the children of God.

Blessed are they which are persecuted for righteousness' sake: for theirs is the kingdom of heaven.

Blessed are ye, when men shall revile you, and persecute you, and shall say all manner of evil against you falsely, for my sake.

Rejoice, and be exceeding glad: for great is your reward in

heaven: for so persecuted they the prophets which were before you.

Ye are the salt of the earth: but if the salt have lost his savour, wherewith shall it be salted? It is henceforth good for nothing, but to be cast out, and to be trodden under foot of men.

Ye are the light of the world. A city that is set on a hill cannot be hid.

Neither do men light a candle, and put it under a bushel, but on a candlestick; and it giveth light unto all that are in the house.

Let your light so shine before men that they may see your good works, and glorify your Father which is in heaven.

Think not that I am come to destroy the law, or the prophets: I am not come to destroy, but to fulfil.

For verily I say unto you, Till heaven and earth pass, one jot or one tittle shall in no wise pass from the law, till all be fulfilled.

Whosoever therefore shall break one of these least commandments, and shall teach men so, he shall be called the least in the kingdom of heaven: but whosoever shall do and teach them, the same shall be called great in the kingdom of heaven.

For I say unto you that except your righteousness shall exceed the righteousness of the scribes and Pharisees, ye shall in no case enter into the kingdom of heaven.

XVII. He raises from the dead the daughter of Jairus

ST. MARK V, verses 22 to 24 and 35 to 43

BEHOLD, there cometh one of the rulers of the synagogue, Jairus by name; and when he saw him, he fell at his feet,

And besought him greatly, saying, My little daughter lieth at the point of death: I pray thee, come and lay thy hands on her, that she may be healed; and she shall live.

And Jesus went with him; and much people followed him, and thronged him.

While he yet spake, there came from the ruler of the synagogue's house certain which said, Thy daughter is dead: why troublest thou the Master any further?

As soon as Jesus heard the word that was spoken, he saith unto the ruler of the synagogue, Be not afraid, only believe.

[He raises from the dead the daughter of Jairus]

And he suffered no man to follow him, save Peter, and James, and John the brother of James.

And he cometh to the house of the ruler of the synagogue, and seeth the tumult, and them that wept and wailed greatly.

And when he was come in, he saith unto them, Why make ye this ado, and weep? the damsel is not dead, but sleepeth.

And they laughed him to scorn. But when he had put them all out, he taketh the father and the mother of the damsel, and them that were with him, and entereth in where the damsel was lying.

And he took the damsel by the hand, and said unto her, Talitha cumi; which is, being interpreted, Damsel, I say unto thee, arise.

And straightway the damsel arose, and walked: for she was of the age of twelve years. And they were astonished with a great astonishment.

And he charged them straitly that no man should know it; and commanded that something should be given her to eat.

The Healing of the Daughter of Jairus

SICULO-BYZANTINE MOSAIC (12th century)

Cathedral of Monreale, Sicily

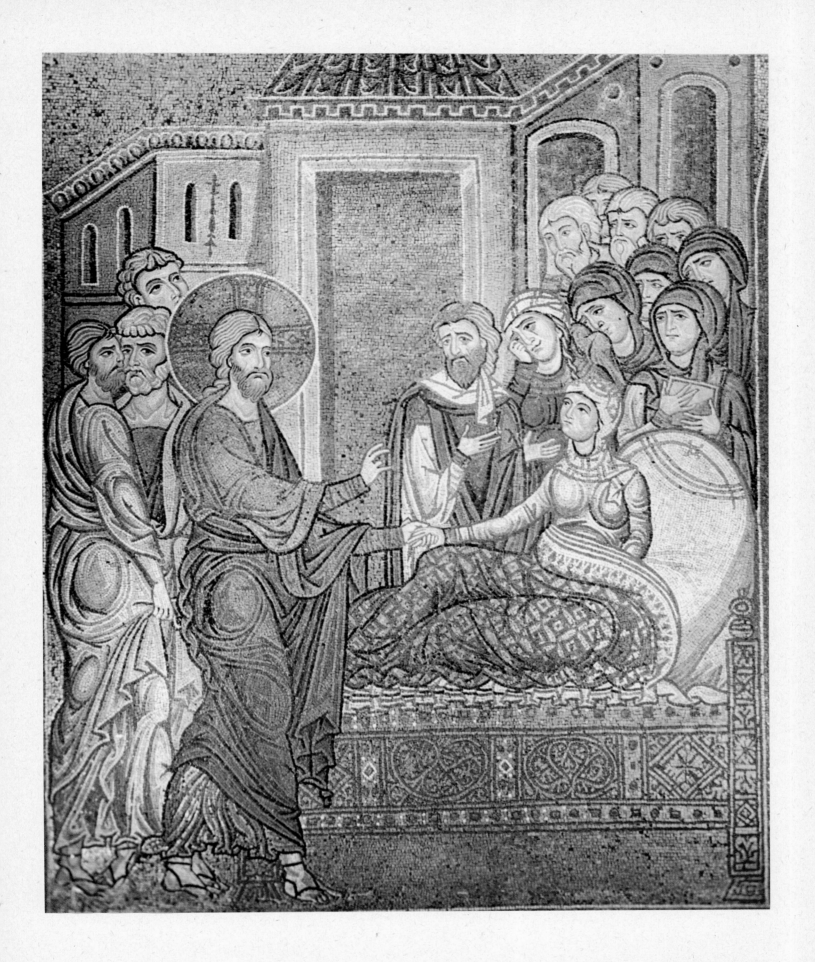

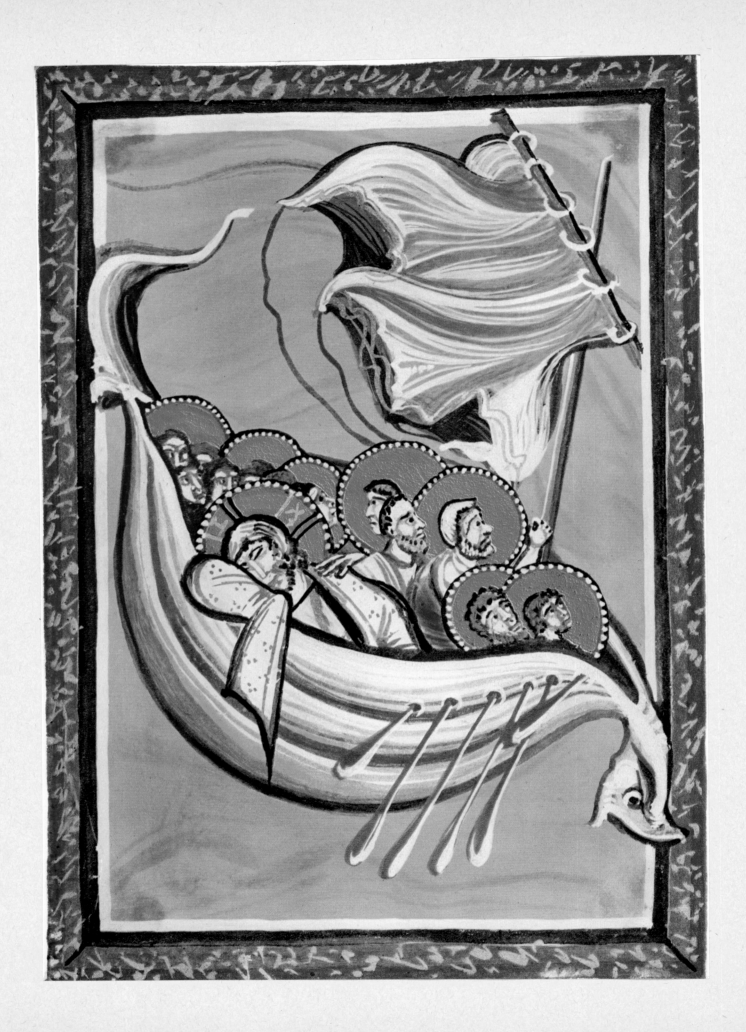

XVIII. In a storm at sea, He is awakened and rebukes the wind

ST. MARK IV, verses 35 to 41

THE same day, when the even was come, he saith unto them, Let us pass over unto the other side.

And when they had sent away the multitude, they took him even as he was in the ship. And there were also with him other little ships.

And there arose a great storm of wind, and the waves beat into the ship, so that it was now full.

And he was in the hinder part of the ship, asleep on a pillow: and they awake him, and say unto him, Master, carest thou not that we perish?

And he arose, and rebuked the wind, and said unto the sea, Peace, be still. And the wind ceased, and there was a great calm.

And he said unto them, Why are ye so fearful? how is it that ye have no faith?

And they feared exceedingly, and said one to another, What manner of man is this, that even the wind and the sea obey him?

XIX. He counsels Peter to pay the tribute money

ST. MATTHEW XVII, verses 24 to 27

AND when they were come to Capernaum, they that received tribute money came to Peter, and said, Doth not your master pay tribute?

He saith, Yes. And when he was come into the house, Jesus prevented him, saying, What thinkest thou, Simon? of whom do the kings of the earth take custom or tribute? of their own children, or of strangers?

Peter saith unto him, Of strangers. Jesus saith unto him, Then are the children free.

Notwithstanding, lest we should offend them, go thou to the sea, and cast a hook, and take up the fish that first cometh up; and when thou hast opened his mouth, thou shalt find a piece of money: that take, and give unto them for me and thee.

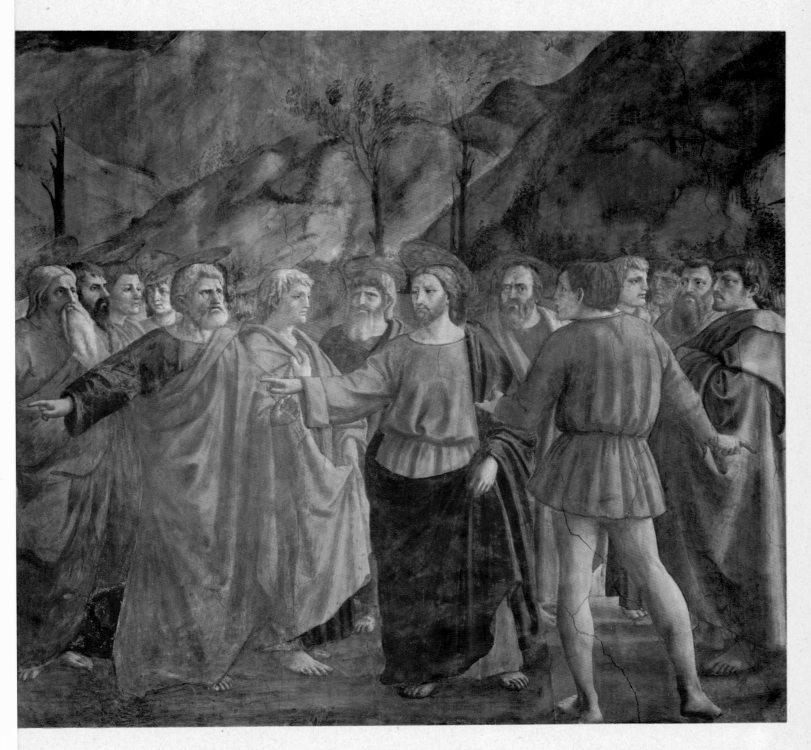

The Tribute Money

MASACCIO (1401–ca. 1428)

Brancacci Chapel, Santa Maria del Carmine,

Florence

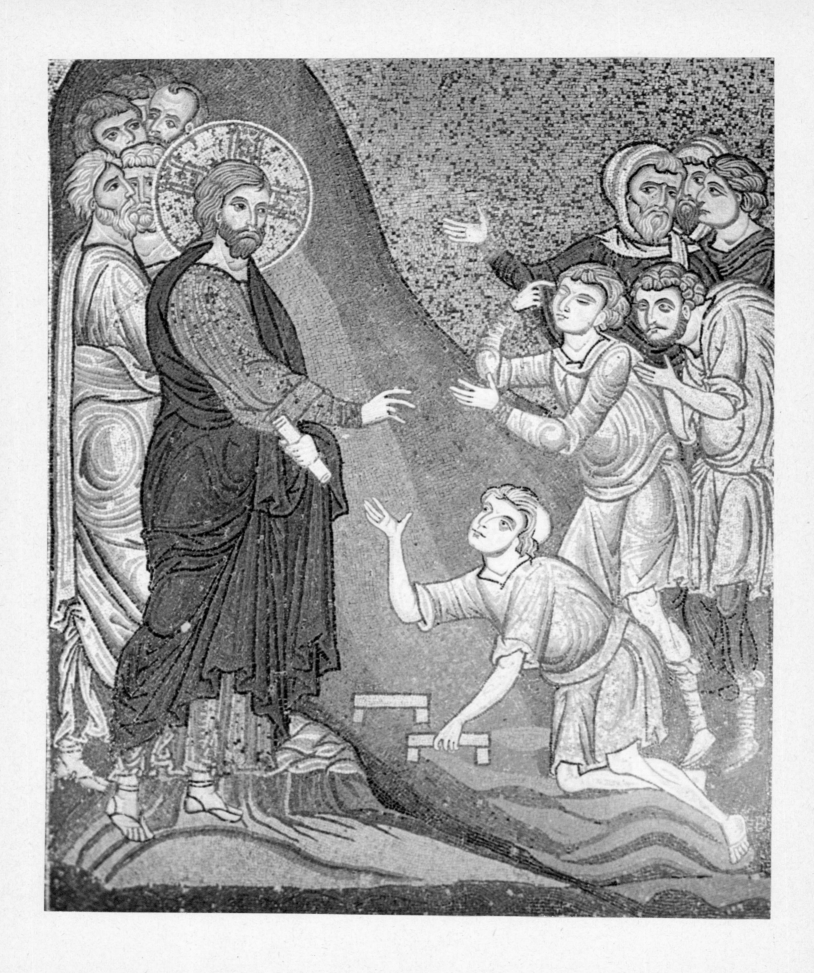

XX. At the Sea of Galilee, He heals the lame, the blind, and the halt

ST. MATTHEW XV, verses 29 to 31

 ND Jesus departed from thence, and came nigh unto the sea of Galilee; and went up into a mountain and sat down there.

And great multitudes came unto him, having with them those that were lame, blind, dumb, maimed, and many others, and cast them down at Jesus' feet; and he healed them:

Insomuch that the multitude wondered, when they saw the dumb to speak, the maimed to be whole, the lame to walk, and the blind to see: and they glorified the God of Israel.

The Healing of the Lame and the Blind

ICULO-BYZANTINE MOSAIC (12th century)

Cathedral of Monreale, Sicily

XXI. Martha is cumbered with serving whilst Mary sits at His feet

ST. LUKE X, verses 38 to 42

IT came to pass, as they went, that he entered into a certain village: and a certain woman named Martha received him into her house.

And she had a sister called Mary, which also sat at Jesus' feet, and heard his word.

But Martha was cumbered about much serving, and came to him, and said, Lord, dost thou not care that my sister hath left me to serve alone? Bid her therefore that she help me.

And Jesus answered and said unto her, Martha, Martha, thou art careful and troubled about many things:

But one thing is needful: and Mary hath chosen that good part, which shall not be taken away from her.

In the House of Mary and Martha

TINTORETTO (1518–1594

Alte Pinakothek, Munich

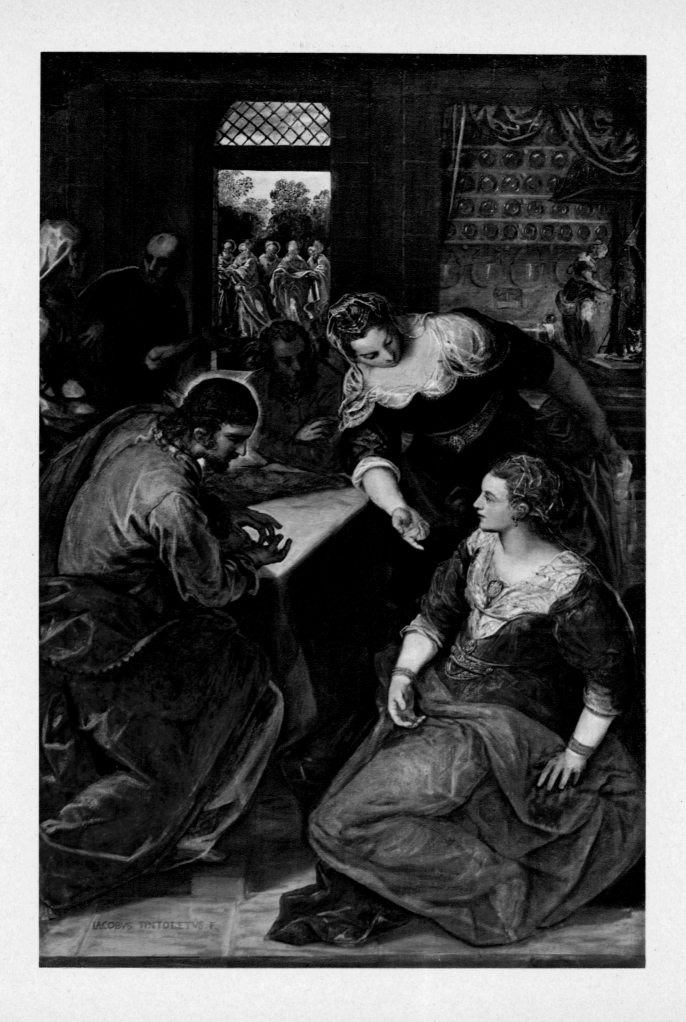

XXII. Out of five loaves and two small fishes He feeds a multitude

ST. JOHN VI, verses 5 to 14

WHEN Jesus then lifted up his eyes, and saw a great company come unto him, he saith unto Philip, Whence shall we buy bread, that these may eat?

And this he said to prove him: for he himself knew what he would do.

Philip answered him, Two hundred pennyworth of bread is not sufficient for them, that every one of them may take a little.

One of his disciples, Andrew, Simon Peter's brother, saith unto him,

There is a lad here, which hath five barley loaves, and two small fishes: but what are they among so many?

And Jesus said, Make the men sit down. Now there was much grass in the place. So the men sat down, in number about five thousand.

And Jesus took the loaves; and when he had given thanks, he

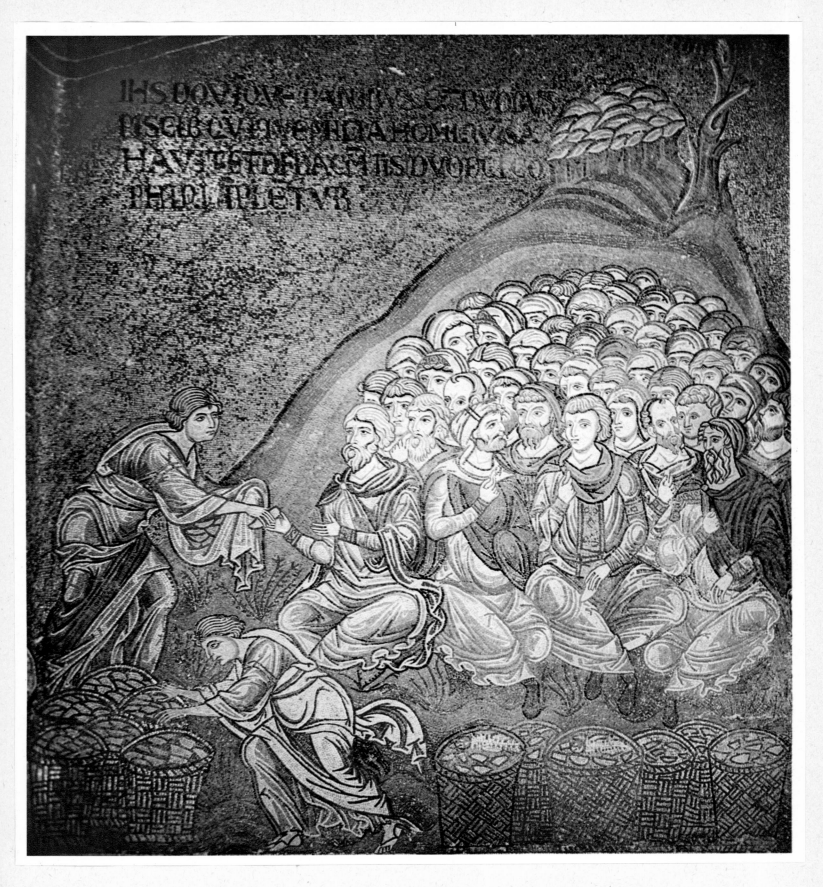

Miracle of the Loaves and Fishes

SICULO-BYZANTINE MOSAIC (*12th century*)

Cathedral of Monreale, Sicily

distributed to the disciples, and the disciples to them that were set down; and likewise of the fishes as much as they would.

When they were filled, he said unto his disciples, Gather up the fragments that remain, that nothing be lost.

Therefore they gathered them together, and filled twelve baskets with the fragments of the five barley loaves, which remained over and above unto them that had eaten.

Then those men, when they had seen the miracle that Jesus did, said, This is of a truth that prophet that should come into the world.

XXIII. Four days after the death of Lazarus, Jesus calls him back to life

ST. JOHN XI, verses 1 to 46

 OW a certain man was sick, named Lazarus, of Bethany, the town of Mary and her sister Martha.

(It was that Mary which anointed the Lord with ointment, and wiped his feet with her hair, whose brother Lazarus was sick.)

Therefore his sisters sent unto him, saying, Lord, behold, he whom thou lovest is sick.

When Jesus heard that, he said, This sickness is not unto death,

but for the glory of God, that the Son of God might be glorified thereby.

Now Jesus loved Martha, and her sister, and Lazarus.

When he had heard therefore that he was sick, he abode two days still in the same place where he was.

Then after that saith he to his disciples, Let us go into Judæa again.

His disciples say unto him, Master, the Jews of late sought to stone thee; and goest thou thither again?

Jesus answered, Are there not twelve hours in the day? If any man walks in the day, he stumbleth not, because he seeth the light of this world.

But if a man walks in the night, he stumbleth, because there is no light in him.

These things said he: and after that he saith unto them, Our friend Lazarus sleepeth; but I go, that I may awake him out of sleep.

Then said his disciples, Lord, if he sleeps, he shall do well.

Howbeit Jesus spoke of his death: but they thought that he had spoken of taking of rest in sleep.

Then said Jesus unto them plainly, Lazarus is dead.

And I am glad for your sakes that I was not there, to the intent ye may believe; nevertheless let us go unto him.

Then said Thomas, which is called Didymus, unto his fellow disciples, Let us also go, that we may die with him.

Then when Jesus came, he found that he had lain in the grave four days already.

Now Bethany was nigh unto Jerusalem, about fifteen furlongs off:

And many of the Jews came to Martha and Mary, to comfort them concerning their brother.

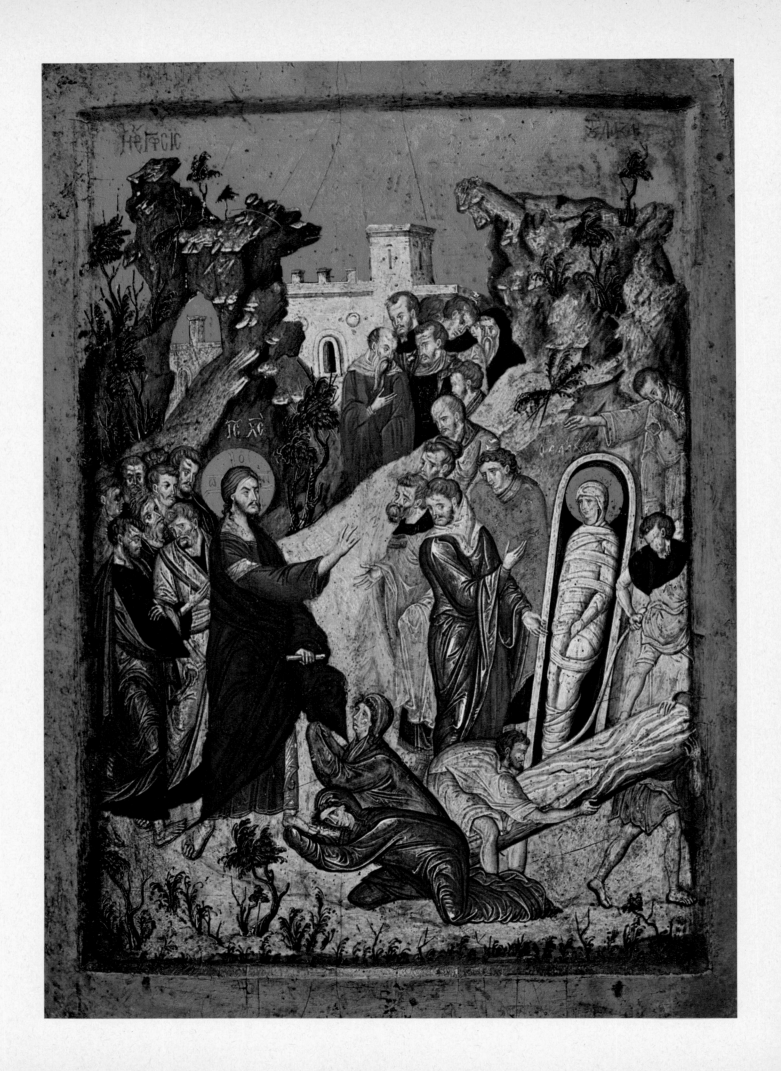

Then Martha, as soon as she heard that Jesus was coming, went and met him: but Mary sat still in the house.

Then said Martha unto Jesus, Lord, if thou hadst been here, my brother had not died.

But I know that even now, whatsoever thou wilt ask of God, God will give it thee.

Jesus saith unto her, Thy brother shall rise again.

Martha saith unto him, I know that he shall rise again in the resurrection at the last day.

Jesus said unto her, I am the resurrection, and the life: he that believeth in me, though he were dead, yet shall he live:

And whosoever liveth and believeth in me shall never die. Believest thou this?

She saith unto him, Yea, Lord: I believe that thou art the Christ, the Son of God, which should come into the world.

And when she had so said, she went her way, and called Mary her sister secretly, saying, The Master is come, and calleth for thee.

As soon as she heard that, she arose quickly, and came unto him.

Now Jesus was not yet come into the town, but was in that place where Martha met him.

The Jews then which were with her in the house, and comforted her, when they saw Mary, that she rose up hastily and went out, followed her, saying, She goeth unto the grave to weep there.

Then when Mary was come where Jesus was, and saw him, she fell down at his feet, saying unto him, Lord, if thou hadst been here, my brother had not died.

When Jesus therefore saw her weeping, and the Jews also weeping which came with her, he groaned in the spirit, and was troubled,

Raising of Lazarus

attributed to ANDRONIKOS BYZAGIOS

(Byzantine, middle 15th century)

The Ashmolean Museum, Oxford

And said, Where have ye laid him? They said unto him, Lord, come and see.

Jesus wept.

Then said the Jews, Behold how he loved him!

And some of them said, Could not this man, which opened the eyes of the blind, have caused that even this man should not have died?

Jesus therefore again groaning in himself cometh to the grave. It was a cave, and a stone lay upon it.

Jesus said, Take ye away the stone. Martha, the sister of him that was dead, saith unto him, Lord, by this time he stinketh: for he hath been dead four days.

Jesus saith unto her, Said I not unto thee that, if thou wouldest believe, thou shouldest see the glory of God?

Then they took away the stone from the place where the dead was laid. And Jesus lifted up his eyes, and said, Father, I thank thee that thou hast heard me.

And I knew that thou hearest me always: but because of the people which stand by I said it, that they may believe that thou hast sent me.

And when he thus had spoken, he cried with a loud voice, Lazarus, come forth.

And he that was dead came forth, bound hand and foot with graveclothes: and his face was bound about with a napkin. Jesus saith unto them, Loose him, and let him go.

Then many of the Jews which came to Mary, and had seen the things which Jesus did, believed on him.

But some of them went their ways to the Pharisees, and told them what things Jesus had done.

XXIV. Entering Jerusalem, Jesus is greeted with hosannas

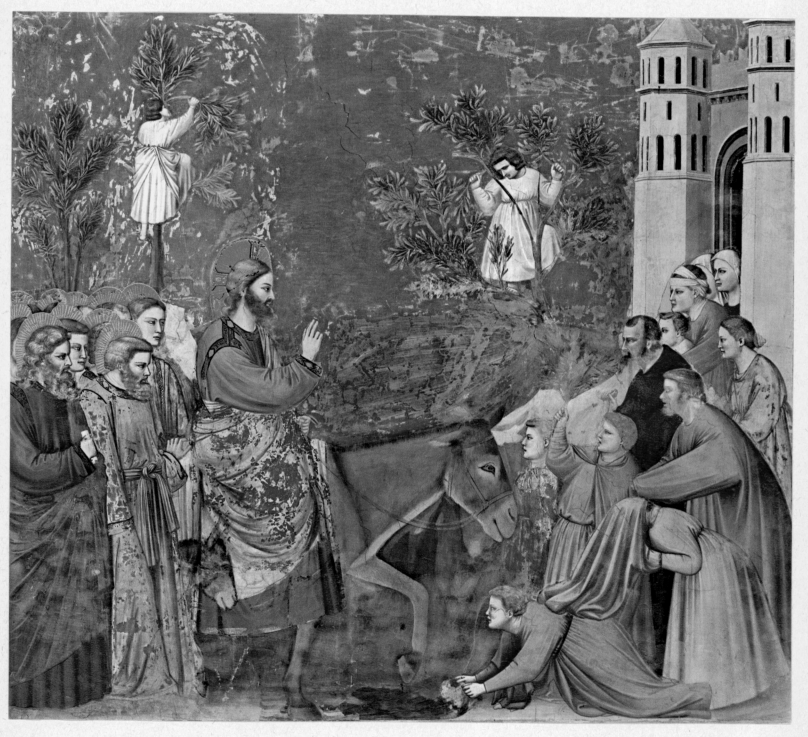

The Entry into Jerusalem

GIOTTO *(1266?–1337)*

Arena Chapel, Padua

ST. MATTHEW XXI, verses 1 to 11

AND when they drew nigh unto Jerusalem, and were come to Bethphage, unto the mount of Olives, then sent Jesus two disciples,

Saying unto them, Go into the village over against you, and straightway ye shall find an ass tied, and a colt with her: loose them, and bring them unto me.

And if any man say ought unto you, ye shall say, The Lord hath need of them; and straightway he will send them.

All this was done, that it might be fulfilled which was spoken by the prophet, saying,

Tell ye the daughter of Sion, Behold, thy King cometh unto thee, meek, and sitting upon an ass, and a colt the foal of an ass.

And the disciples went, and did as Jesus commanded them,

And brought the ass, and the colt, and put on them their clothes, and they set him thereon.

And a very great multitude spread their garments in the way; others cut down branches from the trees, and strewed them in the way.

And the multitudes that went before, and that followed, cried, saying, Hosanna to the son of David: Blessed is he that cometh in the name of the Lord; Hosanna in the highest.

And when he was come into Jerusalem, all the city was moved, saying, Who is this?

And the multitude said, This is Jesus the prophet of Nazareth of Galilee.

XXV. He casts the money-changers out of the temple

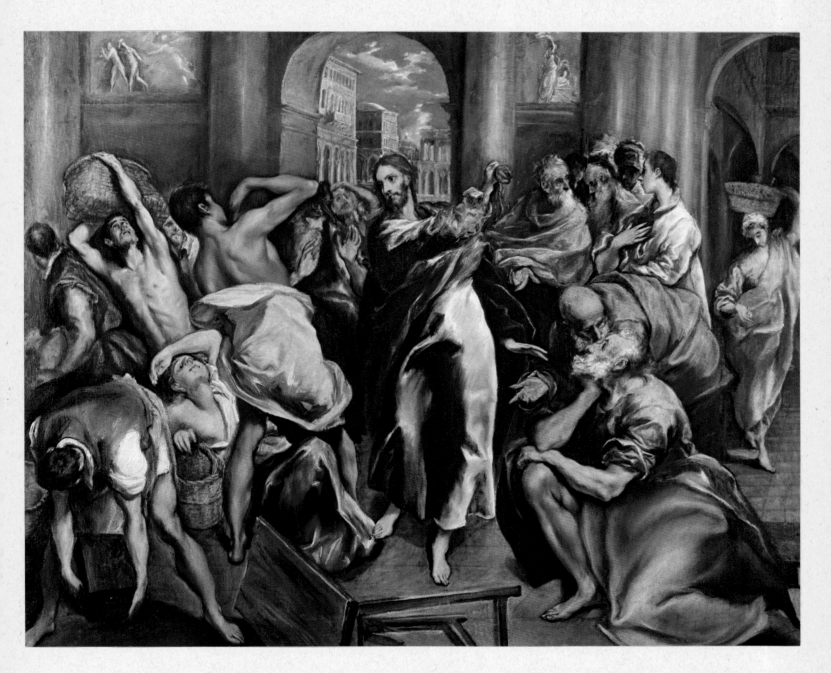

Scourging the Money-changers from the Temple

EL GRECO (1541–1614)

National Gallery, London

ST. JOHN II, verses 13 to 22

THE Jews' Passover was at hand, and Jesus went up to Jerusalem,

And found in the temple those that sold oxen and sheep and doves, and the changers of money sitting:

And when he had made a scourge of small cords, he drove them all out of the temple, and the sheep, and the oxen; and poured out the changers' money, and overthrew the tables;

And said unto them that sold doves, Take these things hence; make not my Father's house a house of merchandise.

And his disciples remembered that it was written, The zeal of thine house hath eaten me up.

Then answered the Jews and said unto him, What sign showest thou unto us, seeing that thou doest these things?

Jesus answered and said unto them, Destroy this temple, and in three days I will raise it up.

Then said the Jews, Forty and six years was this temple in building, and wilt thou rear it up in three days?

But he spoke of the temple of his body.

When therefore he was risen from the dead, his disciples remembered that he had said this unto them; and they believed the scripture, and the word which Jesus had said.

XXVI. He washes the feet of the disciples, saying they should do as He has done to them

ST. JOHN XIII, verses 1 to 20

EFORE the feast of the Passover, when Jesus knew that his hour was come that he should depart out of this world unto the Father, having loved his own which were in the world, he loved them unto the end.

And supper being ended, the devil having now put into the heart of Judas Iscariot, Simon's son, to betray him;

Jesus, knowing that the Father had given all things into his hands, and that he was come from God, and went to God;

He riseth from supper, and laid aside his garments; and took a towel, and girded himself.

After that he poureth water into a basin, and began to wash the disciples' feet, and to wipe them with the towel wherewith he was girded.

Then cometh he to Simon Peter: and Peter saith unto him, Lord, dost thou wash my feet?

Jesus answered and said unto him, What I do thou knowest not now; but thou shalt know hereafter.

[He washes the feet of the disciples, saying they should do as He has done to them]

Peter saith unto him, Thou shalt never wash my feet. Jesus answered him, If I wash thee not, thou hast no part with me.

Simon Peter saith unto him, Lord, not my feet only, but also my hands and my head.

Jesus saith to him, He that is washed needeth not save to wash his feet, but is clean every whit: and ye are clean, but not all.

For he knew who should betray him; therefore said he, Ye are not all clean.

So after he had washed their feet, and taken his garments, and was set down again, he said unto them, Know ye what I have done to you?

Ye call me Master and Lord: and ye say well; for so I am.

If I then, your Lord and Master, have washed your feet; ye also ought to wash one another's feet.

For I have given you an example, that ye should do as I have done to you.

Verily, verily, I say unto you, The servant is not greater than his lord; neither he that is sent greater than he that sent him.

If ye know these things, happy are ye if ye do them.

I speak not of you all: I know whom I have chosen: but that the scripture may be fulfilled, He that eateth bread with me hath lifted up his heel against me.

Now I tell you before it come, that when it is come to pass, ye may believe that I am he.

Verily, verily, I say unto you, He that receiveth whomsoever I send receiveth me; and he that receiveth me receiveth him that sent me.

Christ Washing the Feet of the Disciple

ILLUMINATION from a Vita Chris

(French, 12th century

The Morgan Library, New Yor

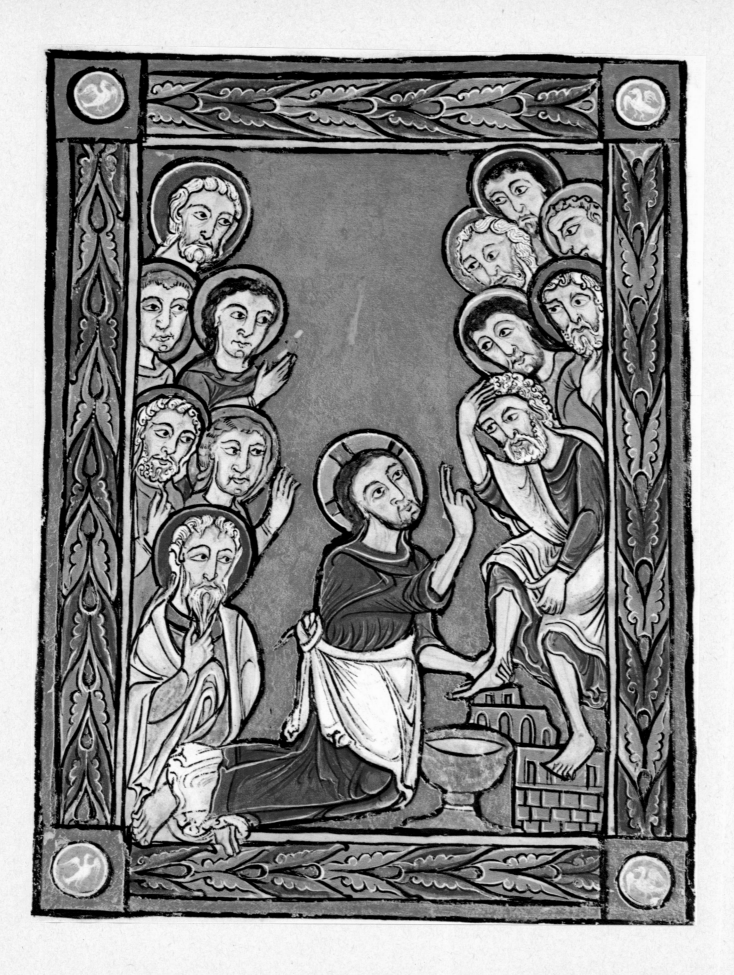

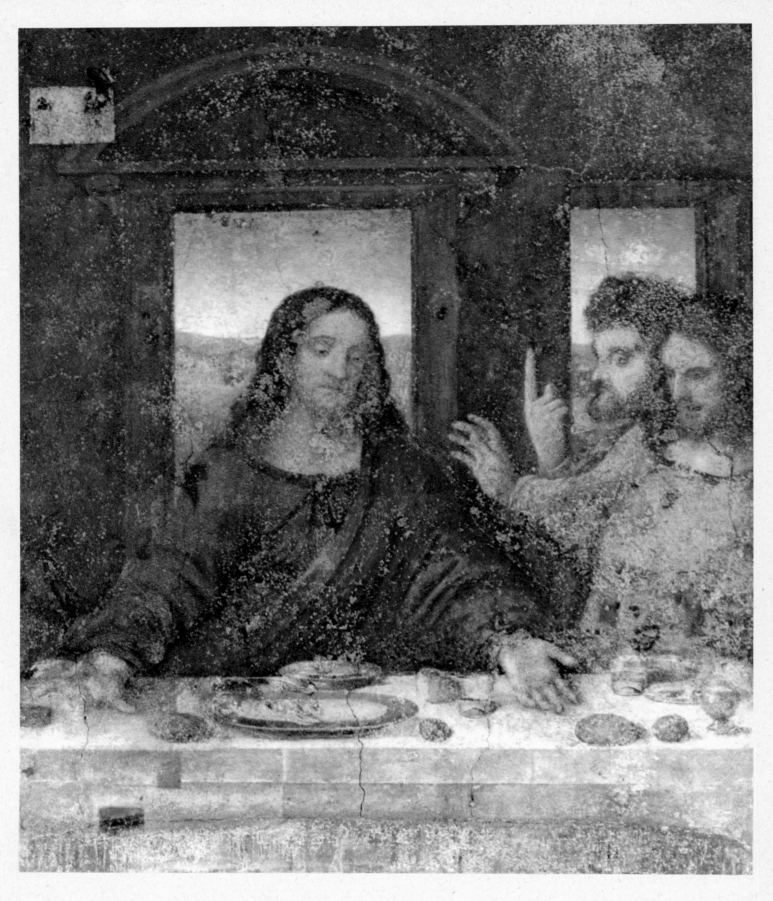

The Last Supper (detail)

LEONARDO DA VINCI (1452–1519)

Santa Maria delle Grazie, Milan

XXVII. At the passover supper
Jesus foretells His betrayal

ST. LUKE XXII, verses 7 to 30

THEN came the day of unleavened bread, when the passover must be killed.

And he sent Peter and John, saying, Go and prepare us the passover, that we may eat.

And they said unto him, Where wilt thou that we prepare?

And he said unto them, Behold, when ye are entered into the city, there shall a man meet you, bearing a pitcher of water; follow him into the house where he entereth in.

And ye shall say unto the goodman of the house, The Master saith unto thee, Where is the guest chamber, where I shall eat the passover with my disciples?

And he shall show you a large upper room furnished: there make ready.

And they went, and found as he had said unto them: and they made ready the passover.

And when the hour was come, he sat down, and the twelve apostles with him.

And he said unto them, With desire I have desired to eat this passover with you before I suffer:

For I say unto you, I will not any more eat thereof, until it be fulfilled in the kingdom of God.

And he took the cup, and gave thanks, and said, Take this, and divide it among yourselves:

For I say unto you, I will not drink of the fruit of the vine, until the kingdom of God shall come.

And he took bread, and gave thanks, and broke it, and gave unto them, saying, This is my body which is given for you: this do in remembrance of me.

Likewise also the cup after supper, saying, This cup is the new testament in my blood, which is shed for you.

But, behold, the hand of him that betrayeth me is with me on the table.

And truly the Son of man goeth, as it was determined: but woe unto that man by whom he is betrayed!

And they began to enquire among themselves, which of them it was that should do this thing.

And there was also a strife among them, which of them should be accounted the greatest.

And he said unto them, The kings of the Gentiles exercise lordship over them; and they that exercise authority upon them are called benefactors.

But ye shall not be so: but he that is greatest among you, let him be as the younger; and he that is chief, as he that doth serve.

For whether is greater, he that sitteth at meat, or he that serveth?

Is not he that sitteth at meat? But I am among you as he that serveth.
Ye are they which have continued with me in my temptations.
And I appoint unto you a kingdom, as my Father hath appointed
unto me;
That ye may eat and drink at my table in my kingdom, and sit
on thrones judging the twelve tribes of Israel.

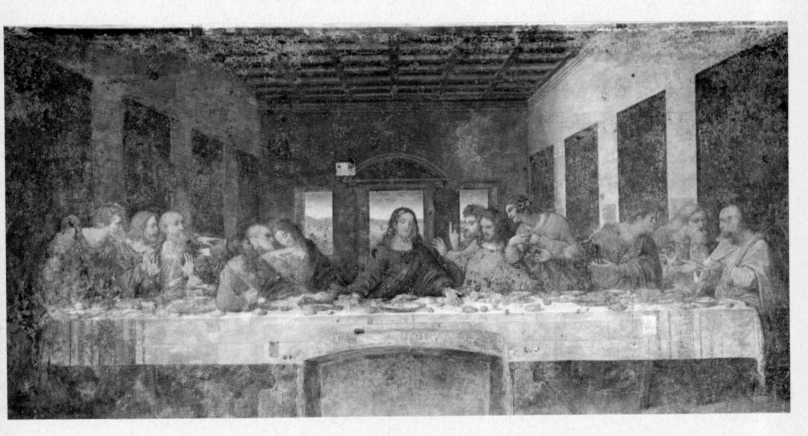

The Last Supper (*as restored in 1954*)

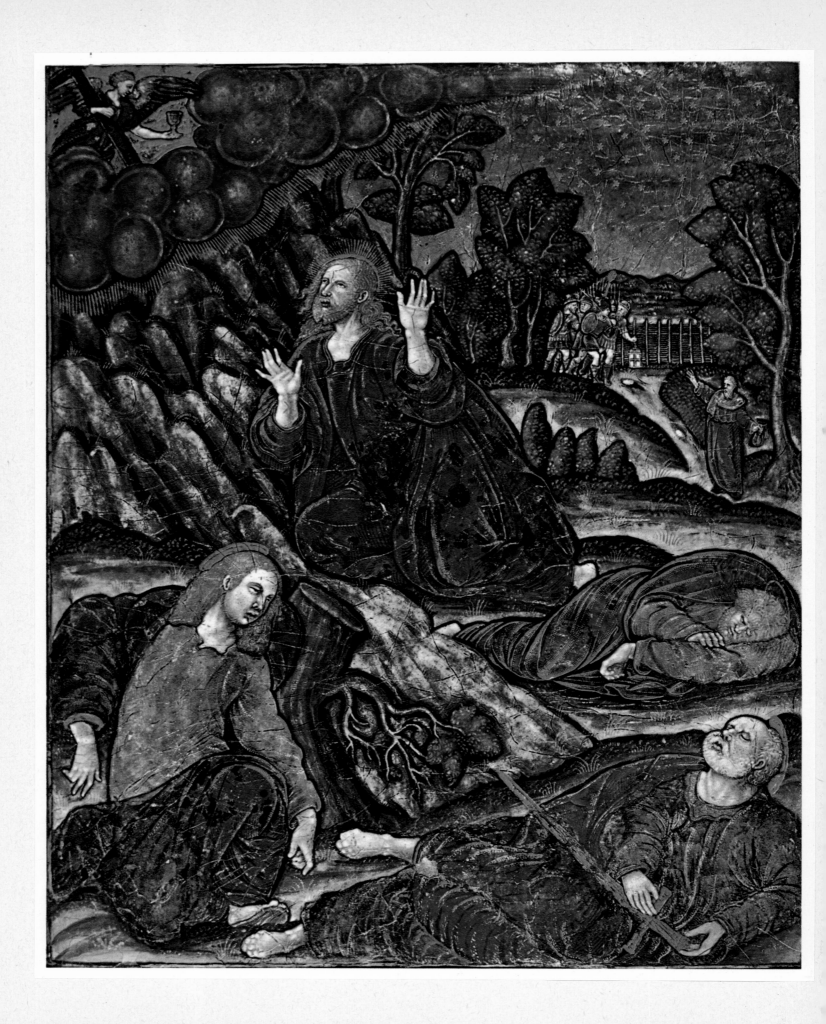

XXVIII. Sorrowing, Jesus prays in the place called Gethsemane

ST. MATTHEW XXVI, verses 30 to 46

AND when they had sung a hymn, they went out into the mount of Olives.

Then saith Jesus unto them, All ye shall be offended because of me this night: for it is written, I will smite the shepherd, and the sheep of the flock shall be scattered abroad.

But after I am risen again, I will go before you into Galilee.

Peter answered and said unto him, Though all men shall be offended because of thee, yet will I never be offended.

Jesus said unto him, Verily I say unto thee, That this night, before the cock crow, thou shalt deny me thrice.

Peter said unto him, Though I should die with thee, yet will I not deny thee. Likewise also said all the disciples.

Then cometh Jesus with them unto a place called Gethsemane, and saith unto the disciples, Sit ye here, while I go and pray yonder.

And he took with him Peter and the two sons of Zebedee, and began to be sorrowful and very heavy.

Agony at Gethsemane

LIMOGES ENAMEL (early 16th century)

Private collection, U.S.A.

[Sorrowing, Jesus prays in the place called Gethsemane]

Then saith he unto them, My soul is exceeding sorrowful, even unto death: tarry ye here, and watch with me.

And he went a little farther, and fell on his face, and prayed, saying, O my Father, if it be possible, let this cup pass from me: nevertheless not as I will, but as thou wilt.

And he cometh unto the disciples, and findeth them asleep, and saith unto Peter, What, could ye not watch with me one hour?

Watch and pray, that ye enter not into temptation: the spirit indeed is willing, but the flesh is weak.

He went away again the second time, and prayed, saying, O my Father, if this cup may not pass away from me, except I drink it, thy will be done.

And he came and found them asleep again: for their eyes were heavy.

And he left them, and went away again, and prayed the third time, saying the same words.

Then cometh he to his disciples, and saith unto them, Sleep on now, and take your rest: behold, the hour is at hand, and the Son of man is betrayed into the hands of sinners.

Rise, let us be going: behold, he is at hand that doth betray me.

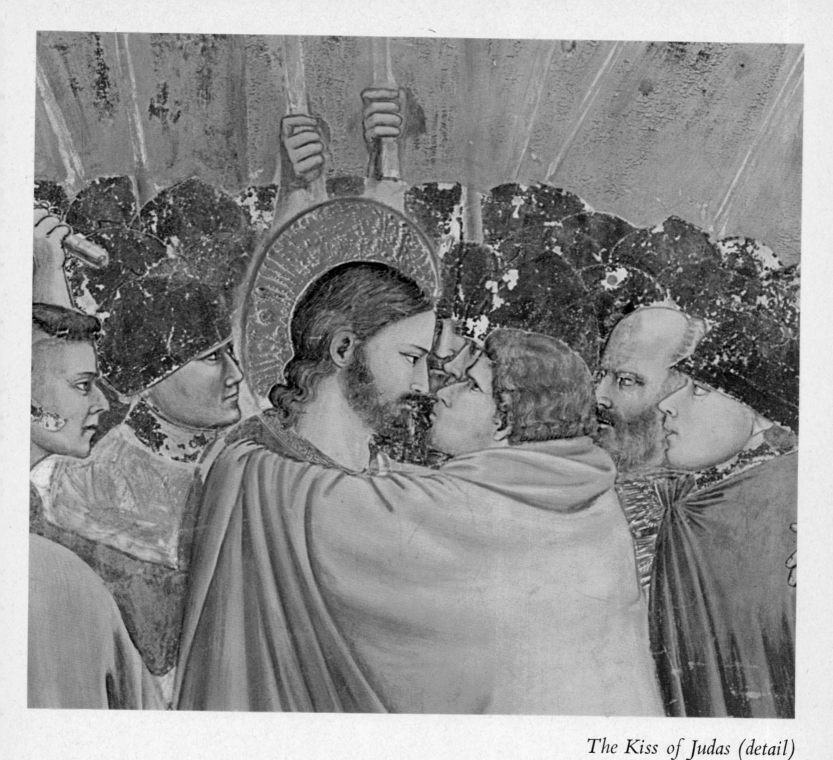

The Kiss of Judas (detail)
GIOTTO (1266?–1337)
Arena Chapel, Padua

XXIX. Judas kisses Jesus,
and a multitude armed with swords
and staves seizes Him

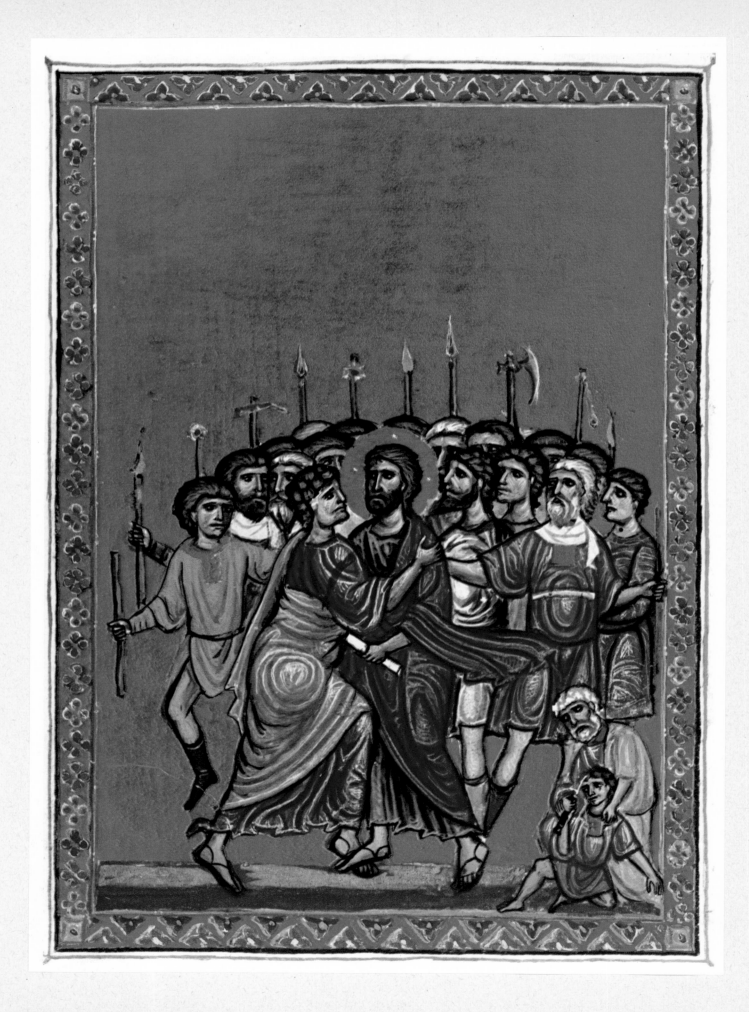

[Judas kisses Jesus, and a multitude armed with swords and staves seizes Him]

ST. MATTHEW XXVI, verses 47 to 56

AND while he yet spoke, lo, Judas, one of the twelve, came, and with him a great multitude with swords and staves, from the chief priests and elders of the people.

Now he that betrayed him gave them a sign, saying, Whomsoever I shall kiss, that same is he: hold him fast.

And forthwith he came to Jesus, and said, Hail, master; and kissed him.

And Jesus said unto him, Friend, wherefore art thou come? Then came they, and laid hands on Jesus, and took him.

And behold, one of them which were with Jesus stretched out his hand, and drew his sword, and struck a servant of the high priest's, and smote off his ear.

Then said Jesus unto him, Put up again thy sword into his place: for all they that take the sword shall perish with the sword.

Thinkest thou that I cannot now pray to my Father, and he shall presently give me more than twelve legions of angels?

But how then shall the scriptures be fulfilled, that thus it must be?

In that same hour said Jesus to the multitudes, Are ye come out as against a thief with swords and staves for to take me? I sat daily with you teaching in the temple, and ye laid no hold on me.

But all this was done, that the scriptures of the prophets might be fulfilled. Then all the disciples forsook him, and fled.

Christ Seized in the Garden

THE MELISSENDA PSALTER

(British, 12th century)

The British Museum, London

XXX. Pilate questions Him: then delivers Him to the soldiers

ST. MATTHEW XXVII, verses 11 to 31

JESUS stood before the governor: and the governor asked him, saying, Art thou the King of the Jews? And Jesus said unto him, Thou sayest.

And when he was accused of the chief priests and elders, he answered nothing.

Then said Pilate unto him, Hearest thou not how many things they witness against thee?

And he answered him to never a word: insomuch that the governor marvelled greatly.

Now at that feast the governor was wont to release unto the people a prisoner, whom they would.

And they had then a notable prisoner, called Barabbas.

Therefore when they were gathered together, Pilate said unto them, Whom will ye that I release unto you? Barabbas, or Jesus which is called Christ?

For he knew that for envy they had delivered him.

When he was set down on the judgment seat, his wife sent unto him, saying, Have thou nothing to do with that just man: for I have suffered many things this day in a dream because of him.

But the chief priests and elders persuaded the multitude that they should ask Barabbas, and destroy Jesus.

The governor answered and said unto them, Whether of the twain will ye that I release unto you? They said, Barabbas.

Pilate saith unto them, What shall I do then with Jesus which is called Christ? They all say unto him, Let him be crucified.

When Pilate saw that he could prevail nothing, but that rather a tumult was made, he took water, and washed his hands before the multitude, saying, I am innocent of the blood of this just person: see ye to it.

Then answered all the people, and said, His blood be on us, and on our children.

Then released he Barabbas unto them: and when he had scourged Jesus, he delivered him to be crucified.

Then the soldiers of the governor took Jesus into the common hall, and gathered unto him the whole band of soldiers.

And they stripped him, and put on him a scarlet robe.

And when they had platted a crown of thorns, they put it upon his head, and a reed in his right hand: and they bowed the knee before him, and mocked him, saying, Hail, King of the Jews!

And they spit upon him, and took the reed, and smote him on the head.

And after that they had mocked him, they took the robe off from him, and put his own raiment on him, and led him away to crucify him.

The Crowning with Thor

TITIAN (1477/87–157

Alte Pinakothek, Mun

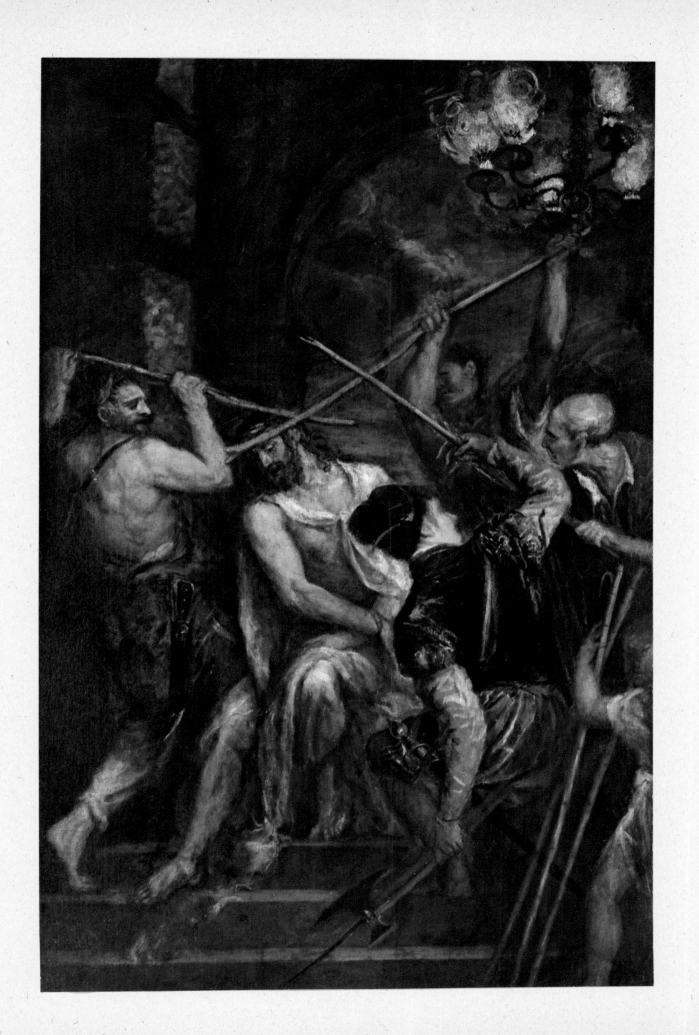

XXXI. Bearing His cross,
He goes forth to Golgotha

ST. JOHN XIX, verses 16 to 18

 HEN delivered he him therefore unto them to be crucified. And they took Jesus, and led him away.

And he bearing his cross went forth into a place called the place of a skull, which is called, in the Hebrew, Golgotha:

Where they crucified him, and two other with him, on either side one, and Jesus in the midst.

The Road to Calvary

TINTORETTO (1518–1594

Scuola San Rocco, Veni

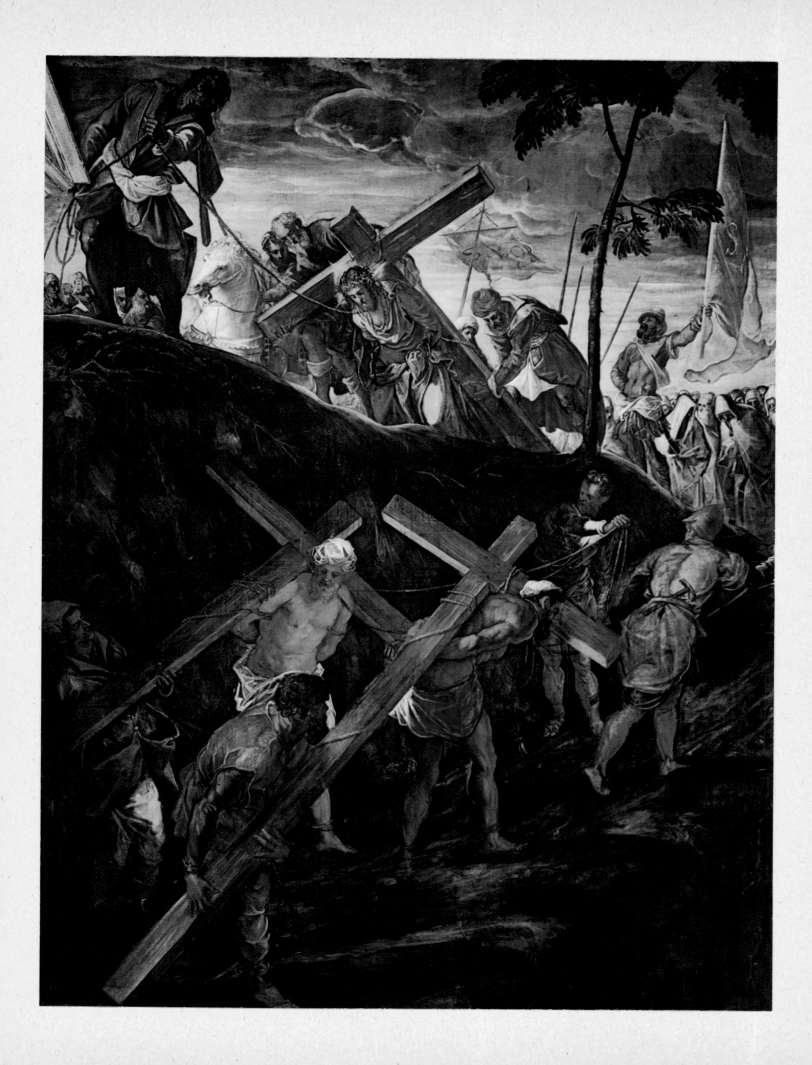

XXXII. He is crucified

ST. LUKE XXIII, verses 33 to 48

AND when they were come to the place which is called Calvary, there they crucified him, and the malefactors, one on the right hand, and the other on the left.

Then said Jesus, Father, forgive them: for they know not what they do. And they parted his raiment and cast lots.

And the people stood beholding. And the rulers also with them derided him, saying, He saved others; let him save himself, if he be Christ, the chosen of God.

And the soldiers also mocked him, coming to him, and offering him vinegar,

And saying, If thou be the king of the Jews, save thyself.

And a superscription also was written over him in letters of Greek, and Latin, and Hebrew, THIS IS THE KING OF THE JEWS.

And one of the malefactors which were hanged railed on him, saying, If thou be Christ, save thyself and us.

But the other answering rebuked him, saying, Dost not thou fear God, seeing thou art in the same condemnation?

And we indeed justly; for we receive the due reward of our deeds: but this man hath done nothing amiss.

And he said unto Jesus, Lord, remember me when thou comest into thy kingdom.

And Jesus said unto him, Verily I say unto thee, Today shalt thou be with me in paradise.

The Piercing of Christ's Side

LIMOGES ENAMEL (15th century)

Taft Museum, Cincinnati, Ohio

XXXIII. In the ninth hour He cries out unto the Lord, Eloi, Eloi, lama sabachthani?

ST. MARK XV, verses 33 to 41

WHEN the sixth hour was come, there was darkness over the whole land until the ninth hour.

And at the ninth hour Jesus cried with a loud voice, saying, Eloi, Eloi, lama sabachthani? which is, being interpreted, My God, my God, why hast thou forsaken me?

And some of them that stood by, when they heard it, said, Behold, he calleth Elias.

And one ran and filled a sponge full of vinegar, and put it on a reed, and gave him to drink, saying, Let alone; let us see whether Elias will come to take him down.

And Jesus cried with a loud voice, and gave up the ghost.

And the veil of the temple was rent in twain from the top to the bottom.

And when the centurion, which stood over against him, saw that he so cried out, and gave up the ghost, he said, Truly this man was the Son of God.

There were also women looking on afar off: among whom was

The Crucifixio

MATTHIAS GRÜNEWALD (1475/80?-152

Kress Collection, National Gallery of A.

Washington, D.

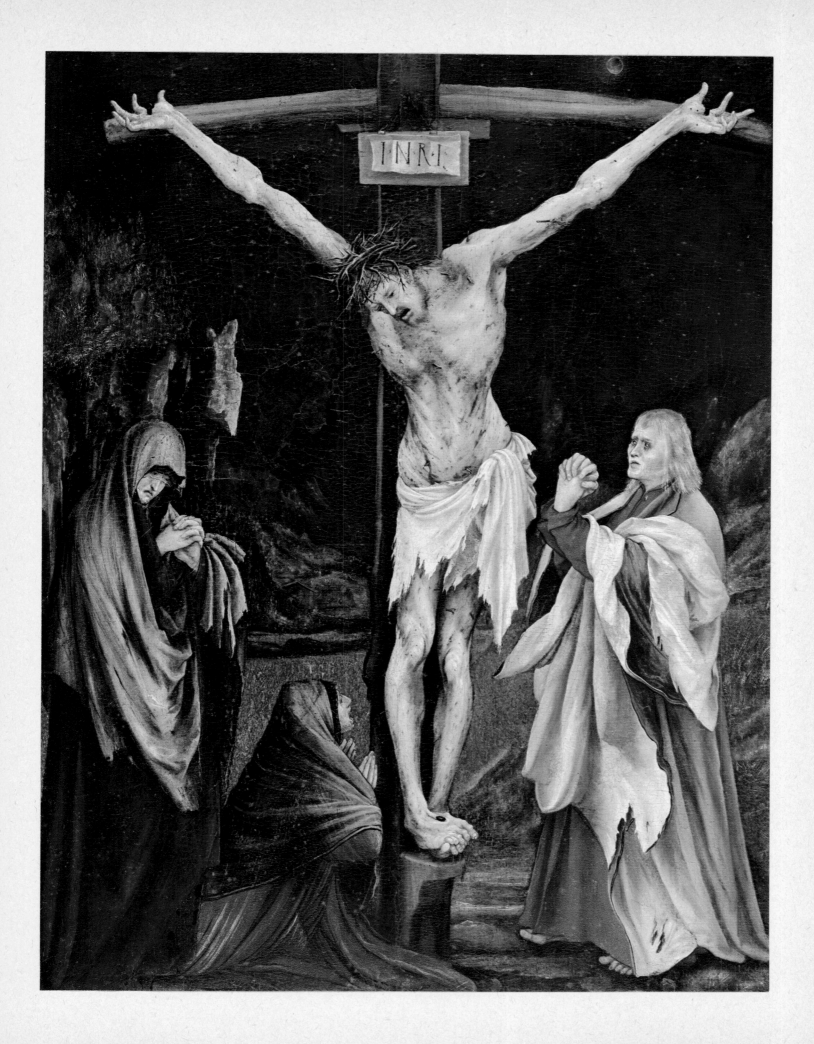

Mary Magdalene, and Mary, the mother of James the Less and of Joses, and Salome;

(Who also, when he was in Galilee, followed him, and ministered unto him); and many other women which came up with him unto Jerusalem.

XXXIV. Secretly the disciples lower His body from the cross

ST. JOHN XIX, verses 38 to 42

AND after this Joseph of Arimathea, being a disciple of Jesus, but secretly for fear of the Jews, besought Pilate that he might take away the body of Jesus: and Pilate gave him leave. He came therefore, and took the body of Jesus.

And there came also Nicodemus, which at the first came to Jesus by night, and brought a mixture of myrrh and aloes, about a hundred pound weight.

Then took they the body of Jesus, and wound it in linen clothes with the spices, as the manner of the Jews is to bury.

The Descent from the Cro

REMBRANDT (1606–166

Widener Collection, National Gallery of A

Washington, D.

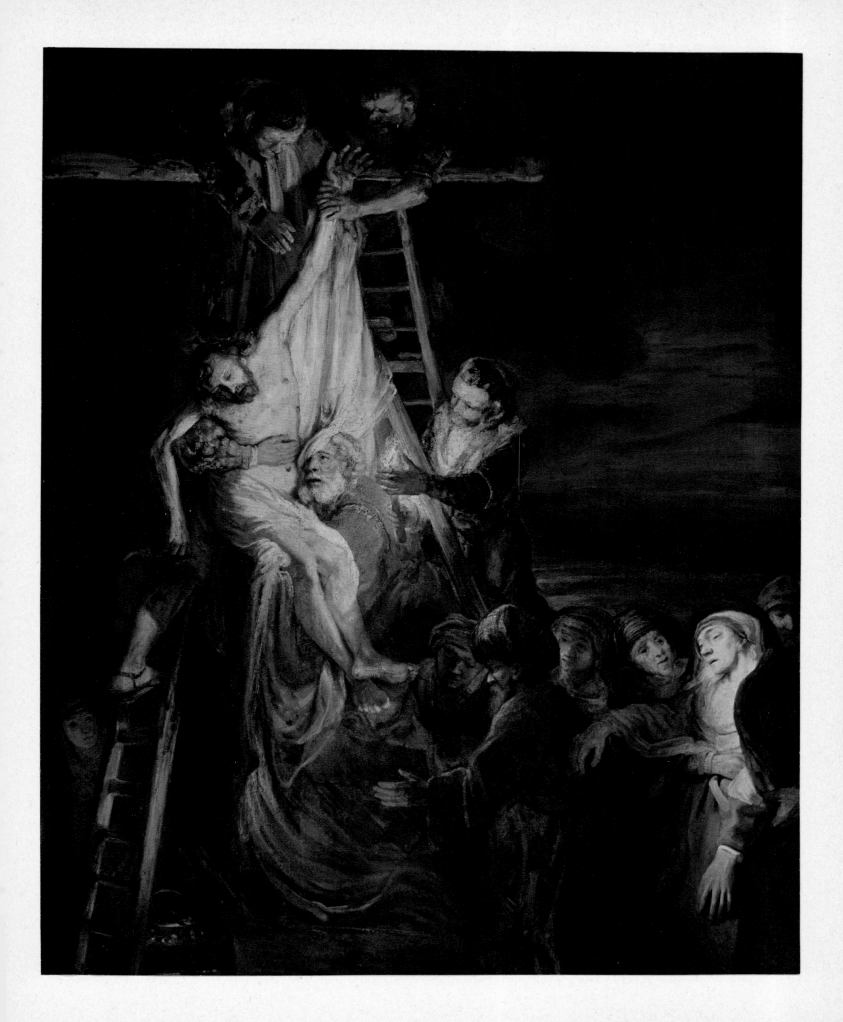

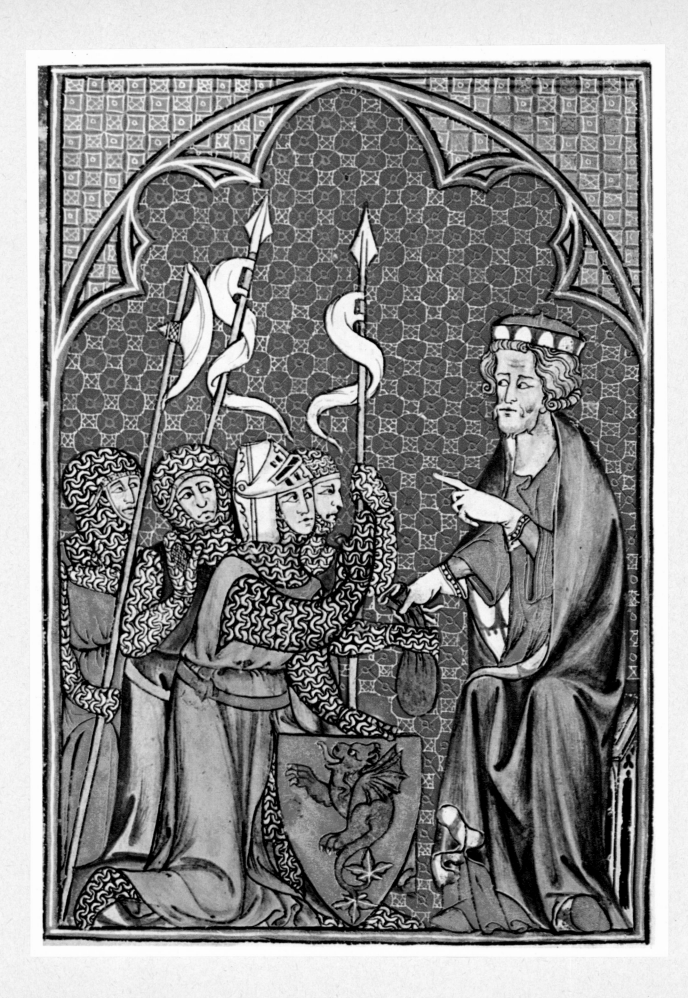

Now in the place where he was crucified there was a garden; and in the garden a new sepulchre, wherein was never man yet laid.

There laid they Jesus therefore because of the Jews' preparation day: for the sepulchre was nigh at hand.

XXXV. Pilate sets a watch over the sepulchre

ST. MATTHEW XXVII, verses 62 to 66

THE next day, that followed the day of the preparation, the chief priests and Pharisees came together unto Pilate,

Saying, Sir, we remember that that deceiver said, while he was yet alive, After three days I will rise again.

Command therefore that the sepulchre be made sure until the third day, lest his disciples come by night, and steal him away, and say unto the people, He is risen from the dead: so the last error shall be worse than the first.

Pilate said unto them, Ye have a watch: go your way, make it as sure as ye can.

So they went, and made the sepulchre sure, sealing the stone, and setting a watch.

XXXVI. At the sepulchre the holy women come upon one who tells them that He is risen

ST. MARK XVI, verses 1 to 8

AND when the Sabbath was past, Mary Magdalene, and Mary the mother of James, and Salome had bought sweet spices, that they might come and anoint him.

And very early in the morning the first day of the week, they came unto the sepulchre at the rising of the sun.

And they said among themselves, Who shall roll us away the stone from the door of the sepulchre?

And when they looked, they saw that the stone was rolled away: for it was very great.

And entering into the sepulchre, they saw a young man sitting on the right side, clothed in a long white garment; and they were affrighted.

And he saith unto them, Be not affrighted: ye seek Jesus of

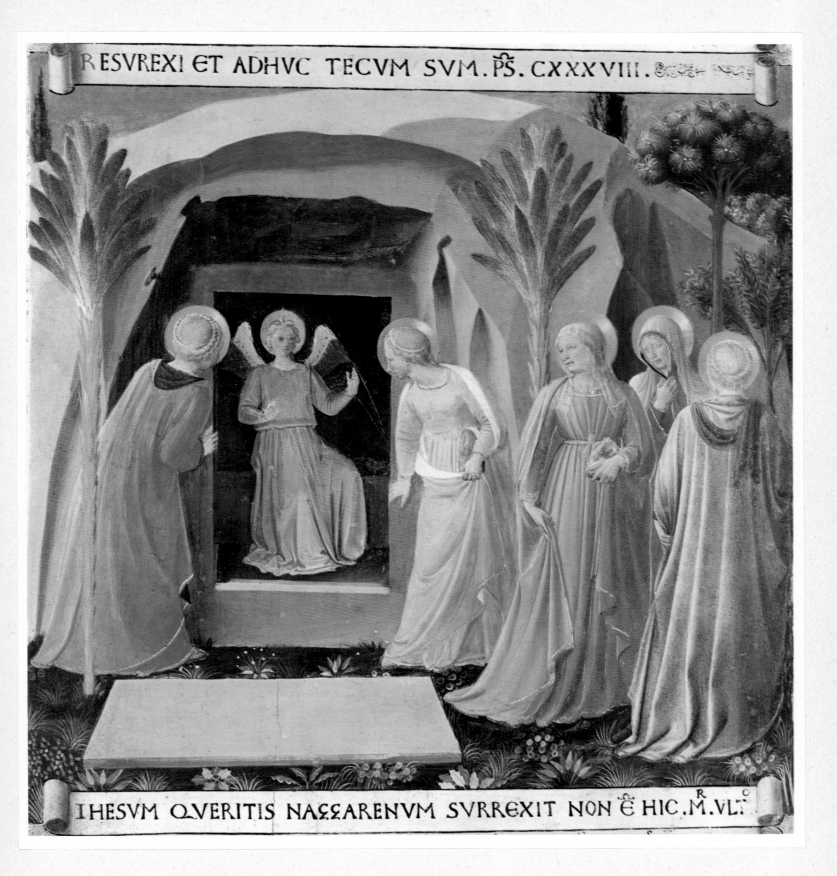

RESVREXI ET ADHVC TECVM SVM. PŚ. CXXXVIII.

IHESVM QVERITIS NAΣΣARENVM SVRREXIT NON Ē HIC. M. VLṬ

The Marys at the Tomb

FRA ANGELICO (1387–1455)

Museo di San Marco, Florence

Nazareth, which was crucified; he is risen; he is not here: behold the place where they laid him.

But go your way, tell his disciples and Peter that he goeth before you into Galilee: there shall ye see him, as he said unto you.

And they went out quickly, and fled from the sepulchre; for they trembled and were amazed: neither said they anything to any man; for they were afraid.

XXXVII. Mary Magdalene meets Jesus, who tells her not to touch Him for He has not yet ascended

ST. JOHN XX, verses 11 to 18

BUT Mary stood without at the sepulchre weeping: and as she wept, she stooped down, and looked into the sepulchre,

And seeth two angels in white sitting, the one at the head, and the other at the feet, where the body of Jesus had lain.

And they say unto her, Woman, why weepest thou? She saith unto them, Because they have

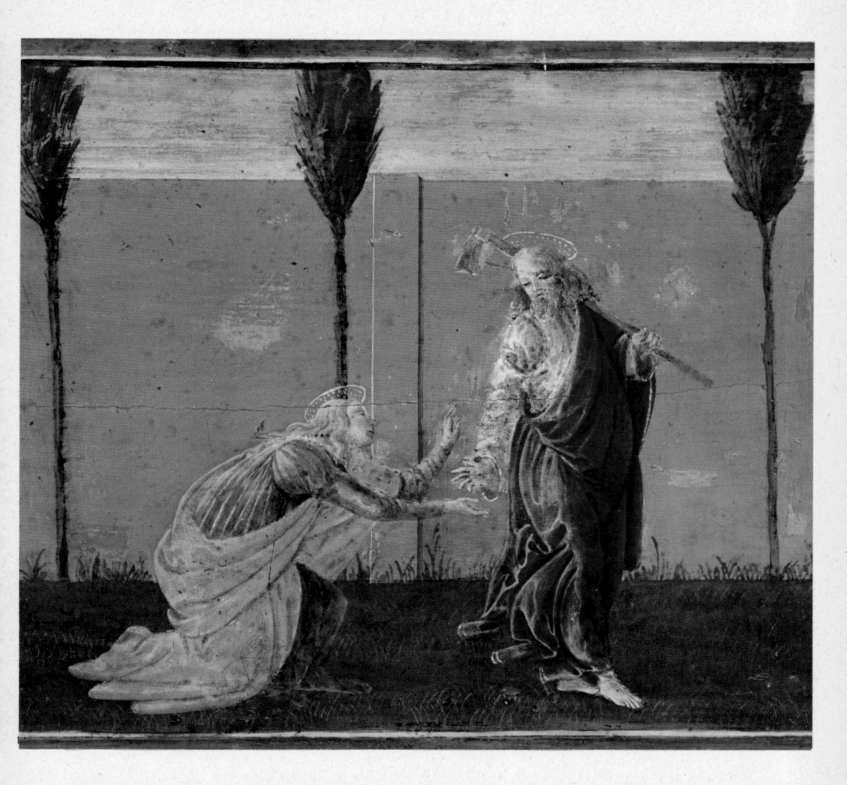

Noli me tangere (detail)

BOTTICELLI (1444/45–1510)

Johnson Collection, Philadelphia Museum of Art

[Mary Magdalene meets Jesus, who tells her not to touch Him for He has not yet ascended]

taken away my Lord, and I know not where they have laid him.

And when she had thus said, she turned herself back, and saw Jesus standing, and knew not that it was Jesus.

Jesus saith unto her, Woman, why weepest thou? whom seekest thou? She, supposing him to be the gardener, saith unto him, Sir, if thou have borne him hence, tell me where thou hast laid him, and I will take him away.

Jesus saith unto her, Mary. She turned herself, and saith unto him, Rabboni; which is to say, Master.

Jesus saith unto her, Touch me not; for I am not yet ascended to my Father: but go to my brethren, and say unto them, I ascend unto my Father, and your Father; and to my God, and your God.

Mary Magdalene came and told the disciples that she had seen the Lord, and that he had spoken these things unto her.

XXXVIII. On the way to Emmaus two of the disciples meet Jesus and He breaks bread with them

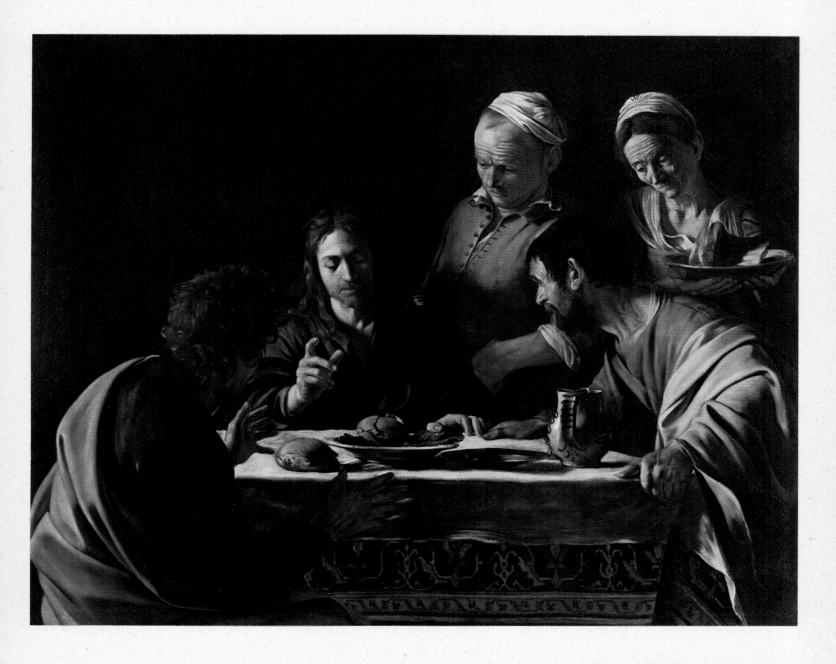

Supper at Emmaus
CARAVAGGIO (1573–1609)
Pinacoteca di Brera, Milan

[On the way to Emmaus two of the disciples meet Jesus and He breaks bread with them]

ST. LUKE XXIV, verses 13 to 35

AND, behold, two of them went that same day to a village called Emmaus, which was from Jerusalem about threescore furlongs.

And they talked together of all these things which had happened.

And it came to pass that, while they communed together and reasoned, Jesus himself drew near, and went with them.

But their eyes were held that they should not know him.

And he said unto them, What manner of communications are these that ye have one to another, as ye walk, and are sad?

And the one of them, whose name was Cleopas, answering said unto him, Art thou only a stranger in Jerusalem, and hast not known the things which are come to pass there in these days?

And he said unto them, What things? And they said unto him, Concerning Jesus of Nazareth, which was a prophet mighty in deed and word before God and all the people:

And how the chief priests and our rulers delivered him to be condemned to death, and have crucified him.

But we trusted that it had been he which should have redeemed Israel: and beside all this, today is the third day since these things were done.

Yea, and certain women also of our company made us astonished, which were early at the sepulchre;

And when they found not his body, they came, saying that they had also seen a vision of angels, which said that he was alive.

And certain of them which were with us went to the sepulchre, and found it even so as the women had said: but him they saw not.

Then he said unto them, O fools, and slow of heart to believe all that the prophets have spoken:

Ought not Christ to have suffered these things, and to enter into his glory?

And beginning at Moses and all the prophets, he expounded unto them in all the scriptures the things concerning himself.

And they drew nigh unto the village, whither they went: and he made as though he would have gone further.

But they constrained him, saying, Abide with us: for it is toward evening, and the day is far spent. And he went in to tarry with them.

And it came to pass, as he sat at meat with them, he took bread, and blessed it, and broke, and gave to them.

And their eyes were opened; and they knew him; and he vanished out of their sight.

And they said one to another, Did not our hearts burn with us, while he talked with us by the way, and while he opened to us the scriptures?

And they rose up the same hour, and returned to Jerusalem, and found the eleven gathered together, and them that were with them,

Saying, The Lord is risen indeed, and hath appeared to Simon.

And they told what things were done in the way, and how he was known of them in breaking of bread.

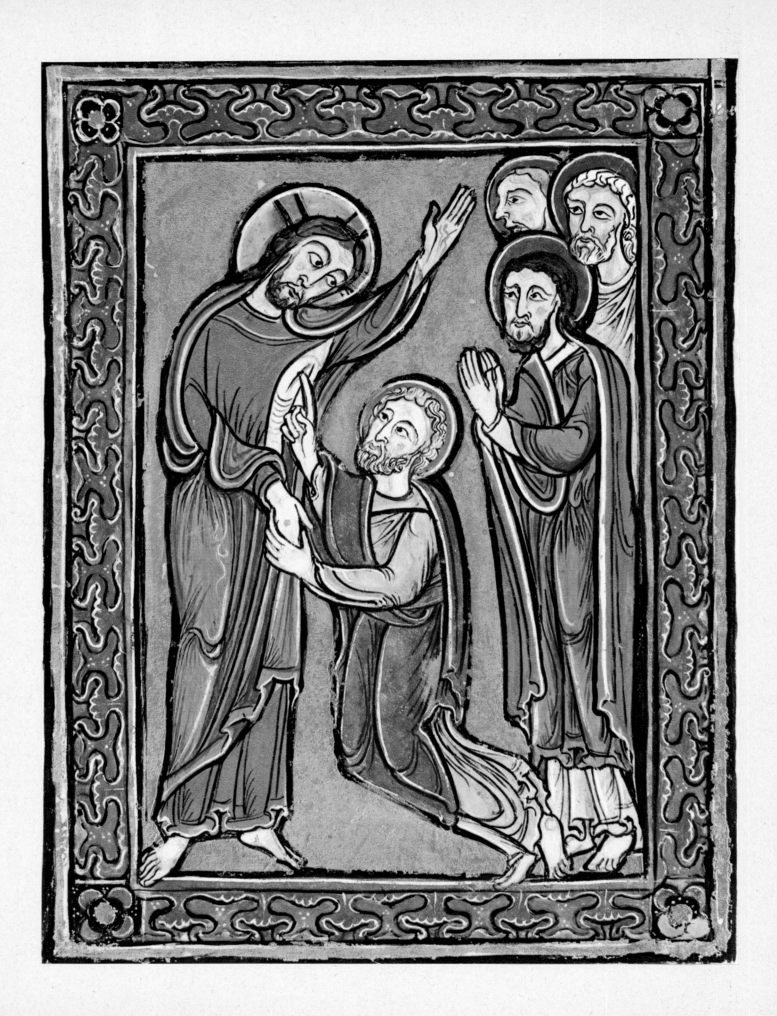

XXXIX. Jesus appears among the disciples but Thomas does not believe until he has thrust his hand into His side

ST. JOHN XX, verses 19 to 29

THEN the same day at evening, being the first day of the week, when the doors were shut where the disciples were assembled for fear of the Jews, came Jesus and stood in the midst, and saith unto them, Peace be unto you.

And when he had so said, he showed unto them his hands and his side. Then were the disciples glad, when they saw the Lord.

Then said Jesus to them again, Peace be unto you: as my Father hath sent me, even so send I you.

And when he had said this, he breathed on them, and saith unto them, Receive ye the Holy Ghost:

Doubting Thomas

ILLUMINATION from a Vita Christi

(French, 12th century)

The Morgan Library, New York

Whose soever sins ye remit, they are remitted unto them; and whose soever sins ye retain, they are retained.

But Thomas, one of the twelve, called Didymus, was not with them when Jesus came.

The other disciples therefore said unto him, We have seen the Lord. But he said unto them, Except I shall see in his hands the print of the nails, and put my finger into the print of the nails, and thrust my hand into his side, I will not believe.

And after eight days again his disciples were within, and Thomas with them: then came Jesus, the doors being shut, and stood in the midst, and said, Peace be unto you.

Then saith he to Thomas, Reach hither thy finger, and behold my hands; and reach hither thy hand, and thrust it into my side; and be not faithless, but believing.

And Thomas answered and said unto him, My Lord and my God.

Jesus saith unto him, Thomas, because thou hast seen me, thou hast believed: blessed are they that have not seen, and yet have believed.

XL. On the shores of Galilee He shows Himself to the disciples

ST. JOHN XXI, verses 1 to 14

AFTER these things Jesus showed himself again to the disciples at the Sea of Tiberias; and on this wise showed he himself.

There were together Simon Peter, and Thomas called Didymus, and Nathanael of Cana in Galilee, and the sons of Zebedee, and two other of his disciples.

Simon Peter saith unto them, I go a fishing. They say unto him, We also go with thee. They went forth, and entered into a ship immediately; and that night they caught nothing.

But when the morning was now come, Jesus stood on the shore: but the disciples knew not that it was Jesus.

Then Jesus saith unto them, Children, have ye any meat? They answered him, No.

And he said unto them, Cast the net on the right side of the ship, and ye shall find. They cast therefore, and now they were not able to draw it for the multitude of fishes.

Therefore that disciple whom Jesus loved saith unto Peter, It is the Lord. Now when Simon Peter heard that it was the Lord, he girt his fisher's coat unto him (for he was naked), and did cast himself into the sea.

And the other disciples came in a little ship (for they were not far from land, but as it were two hundred cubits), dragging the net with fishes.

As soon then as they were come to the land, they saw a fire of coals there, and fish laid thereon, and bread.

Jesus saith unto them, Bring of the fish which ye have now caught.

Simon Peter went up, and drew the net to land full of great fishes, a hundred and fifty and three: and for all there were so many, yet was not the net broken.

Jesus saith unto them, Come and dine. And none of the disciples durst ask him, Who art thou? knowing that it was the Lord.

Jesus then cometh, and taketh bread, and giveth them, and fish likewise.

This is now the third time that Jesus showed himself to his disciples, after that he was risen from the dead.

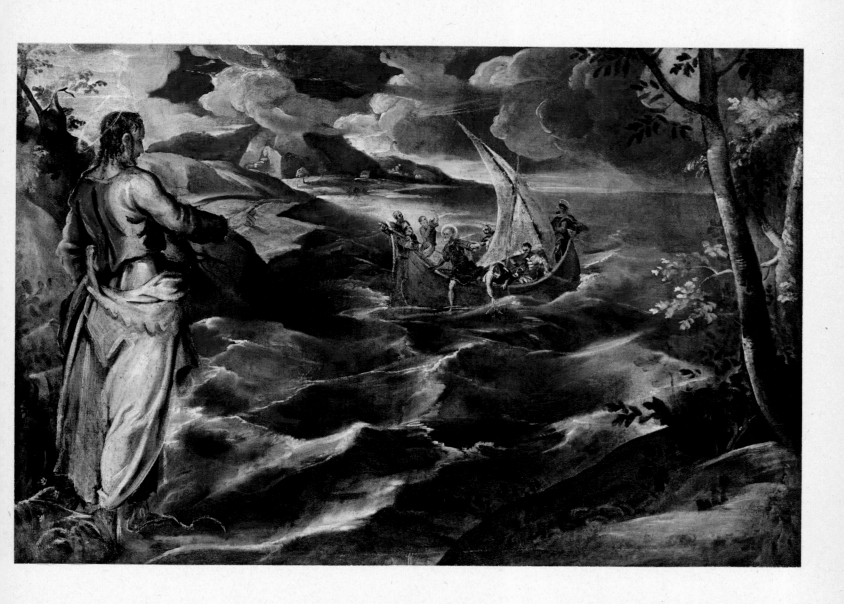

Christ at the Sea of Galilee

TINTORETTO (1518–1594)

Kress Collection, National Gallery of Art,

Washington, D.C.

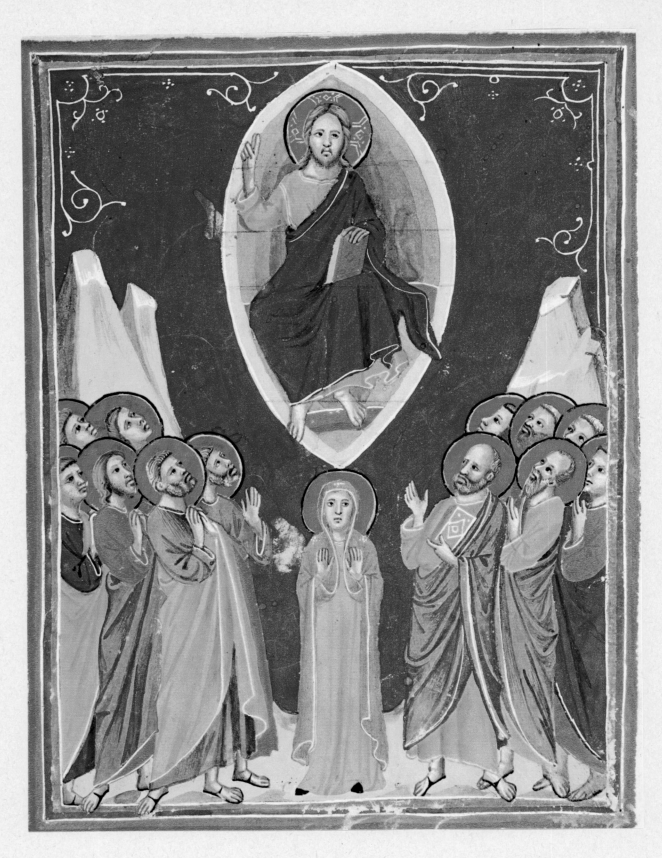

The Ascension

ILLUMINATION *(Florentine, 14th century)*

The Morgan Library, New York

XLI. And He is carried up into heaven

ST. LUKE XXIV, verses 50 to 53

E led them out as far as to Bethany, and he lifted up his hands, and blessed them.

And it came to pass, while he blessed them, he was parted from them, and carried up into heaven.

And they worshipped him, and returned to Jerusalem with great joy:

And were continually in the temple, praising and blessing God.

Amen

Acknowledgments

The publisher is pleased to be able to acknowledge the courtesy and kindness of the institutions (as credited beneath each illustration) that permitted him to reproduce works from their collections.

To those who supplied the photographs, from which the reproductions were made, credit is due as follows:

Ruth Berghaus, Munich: 71
Conzett & Huber, Zurich: 37, 48, 79, 81, 99, 115
Jean et Guy Cussac, Brussels: 31
Fine Art Engravers, London: 33, 42, 71, 76, 94, 108
The Frick Collection, New York: 52
Courtesy of the Philadelphia Museum of Art: 113
Dmitri Kessel, courtesy *Life* Magazine. Copyright,
 Time Inc., New York: 101
Frank Lerner, New York: 28, 41, 51
Life Magazine. Copyright, Time Inc., New York: 93
Francis G. Mayer, New York: 90
Federico Arborio Mella, Milan: 25, 38, 67, 111
The Pierpont Morgan Library, New York: 58, 85,
 118, 124
National Gallery of Art, Washington, D.C.: 45, 55,
 56, 105, 107, 123
Courtesy of the Pinacoteca di Brera, Milan: 86, 89
Josephine Powell, Rome: 63, 68, 73
Herbert Rost, Darmstadt: 64
Courtesy of Skira, Geneva–New York: Title page
Courtesy of the Taft Museum, Cincinnati: 103
Three Lions, New York: 34

THIS BOOK was printed in photogravure and letterpress by Conzett & Huber, Zurich. It was prepared and produced for Harper & Brothers by Chanticleer Press, New York. The design is by James Hendrickson.

The headings are composed in the Centaur types and the text is set in Bembo. The initial letters and decorations have been adapted from designs by Bruce Rogers.